IMAGES
of America

FISHING ON THE
RUSSIAN RIVER

A Pomo baby sits in a papoose board next to a basket in this 1920s photograph. The Pomo people of Sonoma County are world-renowned for their basket-making skills. The Pomo depended on the Russian River not only for fish but also for the basket-making materials that grow along its banks. Baskets were essential for both special ceremonies and everyday practices. (Courtesy of Western Sonoma County Historical Society.)

ON THE COVER: In this 1950s image, a fisherman enjoys a quiet moment on the Russian River at a time when salmon and steelhead runs were still prevalent. In the 1970s, a steep decline in fish populations in Sonoma County spurred a countywide collaboration between local residents, nonprofits, and government agencies to restore the Russian River ecology. (Courtesy of Sonoma County Library.)

IMAGES
of America

FISHING ON THE RUSSIAN RIVER

Meghan Walla-Murphy

ARCADIA
PUBLISHING

Published by Arcadia Publishing
Charleston, South Carolina

Printed in the United States of America

Library of Congress Control Number: 2014935925

For all general information, please contact Arcadia Publishing:
Telephone 843-853-2070
Fax 843-853-0044
E-mail sales@arcadiapublishing.com
For customer service and orders:
Toll-Free 1-888-313-2665

Visit us on the Internet at www.arcadiapublishing.com

*This book is dedicated to the waters of the Russian River
and the return of her salmon for generations to come.*

CONTENTS

ACKNOWLEDGMENTS

I would like to first acknowledge the tenacity and resiliency of the chinook, coho, and steelhead. Their drive and dedication to return to a watershed that has been ravaged is not only the inspiration for this book but also inspires continued passion in my life. These fish epitomize the idea that hope is a verb and not a noun; hope requires action.

I never would have known the magic of these fish without the dozens and dozens of people who helped me better understand the story of these salmon. I would like to thank all of the museums, historical societies, curators, directors, and volunteers who put in countless hours to ensure that our history exists for future generations. Specifically, I give appreciation to the Mendocino County Museum, the Grace Hudson Museum and Sun House, the Healdsburg Museum and Historical Society, the Fort Ross Conservancy, and the Western Sonoma County Historical Society. I offer my thanks to the Sonoma County Library, which continues to swim upstream against a dearth of funds. I am grateful to the local elders, such as Bob Sturgeon and Harry Lapham, who told me their tales. The stories of Dry Creek Pomo tribal members Anthony England and his grandfather Reg Elgin helped me to understand that recovery is possible not only for salmon but also for humans—thank you.

Beyond these keepers of history, I want to offer my sincerest gratitude to the biologists, conservationists, and environmental agencies that have chosen a difficult path in service of neglected species. Thanks to Ben White, the US Army Corps of Engineers, the Gold Ridge Resource Conservation District, the Sonoma County Water Agency, Karen Vogel, David Berman, Bruce MacDonell, Gina Casini, Kate Lundquist, Brock Dolman, and Darlene LaMont.

To Jared Nelson, I thank you for the opportunity to go deeply into my passions and bring them out into the world.

Lastly, I give great kudos to Cagney Pisetsky, who stood by me through the process of writing this book, especially during the few days before the deadline when I turned into a testy bear that wanted to eat these salmon rather than save them.

INTRODUCTION

It has been said that water holds memories. It holds the stories of the land, the animals, and the people it flows through. The waters of the Russian River are no exception. To examine the Russian River's geology, ecology, and anthropogenic history is to reveal a tale of reverence, exploration, destruction, regret, celebration, restoration, and resiliency. As many may have learned in grade school, all rain, snow, clouds, oceans, rivers, and lakes are connected through the water cycle. Like these interconnected waters of the world, the story of the Russian River links people to the struggles of nearly every river in the United States, and there are no better storytellers than the salmon . . .

Imagine a place that is most familiar. Recall the smells, the lighting, perhaps even see the imprint in the spot where you always sit on the couch. Notice the grain of wood at the kitchen table. Imprint on this place. Imprint on home.

Now, imagine an irresistible urge to leave this familiarity. Maybe you are driven by the need for food or the desire to talk with a friend. Maybe it is simply that you have outgrown the comforts of this place. Regardless, you cannot ignore this need to move. You walk out the door into a place vaguely familiar—your neighborhood. Then you round a corner, and things are less familiar. The street is larger, filled with rushing cars and more people you do not know and have never seen before. Perhaps fear rushes in; will you survive the requirements of this place? You join this bustling flow and find yourself at a market. You stock up, choose your favorite foods. Though you do not know where you are going, you do know that you are on a journey. You will need to be fat and healthy if you are to return. For a moment, you are happy to wander the aisles, a seeming relief. Then the urge calls again, and you are travelling once more. This time, you walk away from the bustle and into a vast unknown wilderness. Perhaps the wilds of the Grand Tetons call you, or the epic prairies of the Badlands beckon. Maybe you set off in a boat to sail the oceans. It does not matter, for whichever landscape calls, it is an enormous, uncharted mystery to you.

You spend years in this vastness. During this time, you grow, change, and learn to survive outside the comforts of your familiar place. Though you can still remember the grain of the wood at your kitchen table, you have matured. You would be unrecognizable to those you once knew.

After a few years, you are called again. The urge grabs you, and you cannot shake it. Rather than fight its insistence, you respond. You leave the wilderness, walking differently from when you entered: robust, strong. Once more, you enter the market that you found years ago. You pause again, this time to adjust to a new life. Fatigue from all the movement overcomes you, so you rest in this place. You remember what your favorite food was, how the people move. You remember the smell of this place.

You leave the market and head back up the bustling, rushing road filled with cars and strangers. The fear you once felt is no more. Again, you are driven to move at all costs. Nothing can stop you. You round the corner and walk down your neighborhood street. Perhaps you wave hello to the people who live next door. You walk though your front door and sit comfortably in the imprint you left in the couch. Ease settles over you. You know this place, the smells, and the light. You are home.

Once home, you know what you must do. Maybe it involves creating great art or starting a family. Regardless, you are relentless in this drive to fulfill your legacy until everything you have is given up—until you are spent.

If any of this journey rings true, feels familiar, or compels you, you may understand the life of anadromous fish like the salmon and steelhead of the Russian River. These fish, born in fresh water, spend the bulk of their lives in the salty ocean but, to spawn, return to the freshwater natal tributaries where they were born. Though they lead an arduous life, their lives are also epic journeys on the scale of that of Odysseus in Homer's *Odyssey*.

Three special-concern salmonids (fish in the *Salmonidae* family) live in the Russian River—chinook, coho, and steelhead trout. These species once numbered in the thousands, but their populations have steadily declined in the past century to such a degree that the return of only six wild coho is cause for celebration.

Though details differ amongst the three species, their life cycles share many similarities. Salmonids begin their lives as eggs in a redd, or nest, dug into the gravelly, silt-free bottom of a small tributary. Between March and May, the eggs hatch, and miniscule translucent alevin emerge still attached to yolk sacs larger than their bodies. During this vulnerable time, they seek refuge from predators and swiftly moving water. As they grow into fry, only a few inches long, they remain in deep, still pools for protection and nourishment. After a few months to a year—depending on the species—fry develop into smolts.

The mechanisms of imprinting remain elusive, but smolts imprint on their natal tributaries, memorizing the smells, contours, and perhaps lighting of the streambed. Then, the smolts respond to an ancient call urging them to swim downstream, away from the familiar, and into the main stem of the Russian River as they head toward the mouth of the river. During this time, the small smolts navigate swiftly-moving waters, avoid predation, and face many challenges related to human development. On the way to the mouth, the smolts pause in the estuary near Jenner. This essential pause allows them to undergo smoltification, when the smolts grow in length, take on weight, and experience physiological changes that prepare them for saltwater life in a marine environment. After swimming the estuary, they enter the ocean and remain there for two to three years.

While in the ocean, another call urges them back to the Russian River. Upon reaching the mouth, they pause at the estuary to rest after their oceanic sojourn and to readjust to life in fresh water. From there, they swim upstream in high winter flows. Through cues undetectable to human senses, they find their natal tributaries. The females search for an adequate place to lay eggs, and the males compete for the chance to fertilize. She turns on her side and flips her tail into the gravelly bottom to dig an oval-shaped depression in the streambed. She then waits until a virile male arrives and triggers her to lay eggs. She will deposit several hundred, then the male deposits his milt (sperm) before other males intrude. From there, the female moves a bit upstream and builds another redd. The gravel she dislodges covers the eggs in the first redd so that they are buried and protected from predators and changing stream conditions. The cycle begins again.

For coho and chinook, spawning brings them to the end of their lives. Steelhead may spawn several times before reaching the ends of their life spans. Regardless of when the fish die, their legacies continue as part of the anadromous nutrient cycle. When fish populations thrived, their carcasses littered the banks of the Russian River system after spawning, providing the ecosystem with abundant nutrients. Birds, other fish, and small and large mammals took advantage of this abundance. Bears would scour the banks to feed on the carcasses. Once satiated, they wandered back to the woods and defecated the salmon's nutrients as fertilizer. The uneaten carcasses decayed, and surrounding vegetation leached important minerals from the soil. The salmon moved necessary marine nutrients to the land on a kind of trade route between the aquatic and terrestrial.

The declining populations of salmonids are now taking their toll. Valuable nutrients are missing from what was once a healthy, functioning habitat, and the entire ecosystem lacks in fecundity and viability. So dire is this loss that biologists distribute hatchery carcasses across the landscape to help replenish nutrient deficiencies even though the carcasses lack oceanic minerals. Other innovative ecologists are creating nutrient pellets to be dropped on riverbanks to replace the missing salmon. However, these strategies simply place a small bandage over a huge, festering wound that is centuries old.

To complete their legacy and life cycle, chinook, coho, and steelhead need river systems with complexity, meanders, woody debris, and deep pools. They need gravel streambeds free from silt. They need safe estuaries in which to adjust to changing developmental stages. They need refuge from pollutants and a respite from overfishing in the oceans.

Above all else, they need water.

Neglect, manipulation, and overuse of our rivers and fisheries all lie at the root of declining salmon and steelhead populations. Over the centuries, the Russian River has seen many iterations of its flow. Native Pomo built communal fish dams and weirs each year during the migrations. Though these barriers shifted the patterns of the river, it was a temporary change that lasted only until the dams were lifted after a few weeks. With the arrival of early Europeans and settlers, the river was once again subjected to different fluctuations. Logging, railroads, and dams permeated the landscape and left wounds in the watershed that still have yet to heal.

Of all the man-made manipulations, perhaps the most drastic came with the Potter Valley Project (PVP). The mouth of the Eel River lies 200 miles north of the mouth of the Russian, but in Potter Valley, only two miles separate their headwaters. In 1908, humans built a mile-long diversion tunnel that streamed water from the Eel into the Russian. This extra water provides electricity for Potter Valley and water for irrigation. Yet the diversion has depleted water supplies in the Eel, collapsed Eel salmon runs that once exceeded 500,000 fish, and created unnaturally high flows in the Russian. Today, the Russian River is the only river in California that contains more water than it did 100 years ago. This seemingly good idea has wreaked havoc on both watersheds, and a recent biological opinion produced by the National Marine Fisheries Service regarding flows in the Russian River mandates that federal, state, and county agencies account for this engineering debacle.

Other than the PVP, various other factors contribute to the struggles of the Russian River. Over 500 dams are permitted along the Russian, including the Coyote and Warm Springs Dams that create Lake Mendocino and Lake Sonoma, respectively. Dams impact salmon and steelhead in a number of ways, from creating reservoirs that inundate spawning areas to changing historic flow patterns and raising water temperatures. They also block passage of salmon and steelhead during migrations.

To mitigate these losses, hatcheries are built near dams. Early hatchery practices designed to replace lost fish only accelerated the demise of wild populations; hatchery managers released large numbers of fish without understanding how they would compete with wild salmon for resources. The large numbers of fish released from hatcheries also masked the true loss of wild salmon for decades, delaying human response to the problem. Hatcheries cannot eliminate the issue of widespread habitat loss—even hatchery fish must have a place to live. Habitat destruction has lead to the extinction of 106 major salmon runs on the West Coast, and 25 more are now on the federal endangered species list.

Steelhead and salmon face other issues as well. No matter the species of salmonid, all use freshwater stream or lakeshore gravel to dig nests and lay eggs. More than a century of mining of the Russian River gravel beds has dwindled spawning habitat. In addition, the sediment runoff from agriculture and logging practices renders streambeds unusable for reproduction. If the gravel is missing or too many fine sediments have infiltrated the gravel, eggs laid in such conditions will suffocate from the lack of oxygen.

Stream incision caused by straightening of channels, loss of riparian vegetation, and changes in watershed land use also spell doom for salmonid survival. Because incised streams are typically unstable and function poorly, they are good candidates for stream-restoration projects, which enhance fish habitat. Characteristics of healthy functioning streams include pools, riffles, steps, meanders, and flood plains. Though these traits can be related to climate, geology, topography, and vegetation, current land use practices need to be addressed to mitigate incision.

Fish Friendly Farming, biodynamic farming, permeable road surfaces, and other techniques help slow salmonid loss, but success will only come with large-scale collaboration amongst all of

the different people who use the resources of the Russian River. (Examples of these collaborative efforts are shared in subsequent chapters.) In all river systems, the networking tributaries are vast and unknown, as is the solution to helping salmonid populations recover. There are still many deep pools, eddies, and streams to be explored to fully understand the story of the Russian River salmon.

The fish are indicators. They are our first line of defense when responding to the conditions of our watersheds. Coho biologist Ben White often says, "water equals fish." The sentence is simple, concise, and deceptively obvious. If there are no salmon, what does that say about our water? Like fish, humans also cannot live without water.

Given all this dark gloom, many question: Why bother? Does it matter? Is there hope? The author's answer: without a doubt. The resilience and tenacity of salmonids is extraordinary. These fish migrate thousands of miles in just a few years, through oceanic wilderness, only to return to their homelands to reproduce and replenish the ecosystem that once nurtured them.

In recognition of this miraculous feat, hundreds of residents and multiple local nonprofit and government agencies have united to dedicate resources to the return of the salmon. For some, it is simply a question of biology—for others, economy—but salmon are deeply rooted in our history. Ceremonies, songs, stories, and cultures honor this totemic species. The extinction of salmon would be more than just another species extirpated; a cultural ethic—a sustainable way of interacting with water and nature—would be lost.

One

THE RIVER

Over the millennia, the Russian River has been called different names by the different people living along its shores and drinking from its waters.

The Pomo tribal people have called the river *Ashokawna*, meaning east water place, or *Bidapte*, for big river. In the early 1800s, Russian naval commander Otto Von Kotzebue recorded the native people of the area naming the river *Shabaica* or *Sacabaya*. Early Russian settlers called the river *Slavyanka*, which translates as "little dancing girl." The Spanish called the river *San Ygnacio*, and an 1843 land grant names it the *Rio Grande*. Other names include *Misallaako, Rio Ruso*, and *Shabaikai*.

The river's main stem flows southward from its headwaters in the Laughlin range near Willits, then joins with its east fork below the Mendocino Dam northeast of Ukiah. The Russian River flows past Cloverdale and into Sonoma County, where it passes vineyards, dairy farms, and recreational river towns before draining into the Pacific Ocean at Jenner. The 110-mile journey of the main stem belongs to an entire watershed system that drains 1,485 square miles (one million acres) of water. This water quenches the thirst of more than 600,000 people in Sonoma and Marin Counties.

Housed within that watershed are diverse habitats including redwood forest, oak woodland, coniferous and mixed hardwood forests, chaparral, willow thickets, wetlands, and native and nonnative grasslands. Each of these unique habitats allows for a multitude of aquatic and terrestrial animals to thrive.

Early historical records tell of a time when elk, beaver, otter, grizzly, cougar, and native trout and salmon densely populated the riverscape. But due to fur trapping, trophy hunting, recreation, industrialization, and development, some of these species have been eradicated or are facing peril because of a compromised ecosystem.

Thankfully, in the case of species such as otter, beaver, and bear, their numbers are once again growing in the Russian River watershed; this is also the case with the steelhead, coho, and chinook.

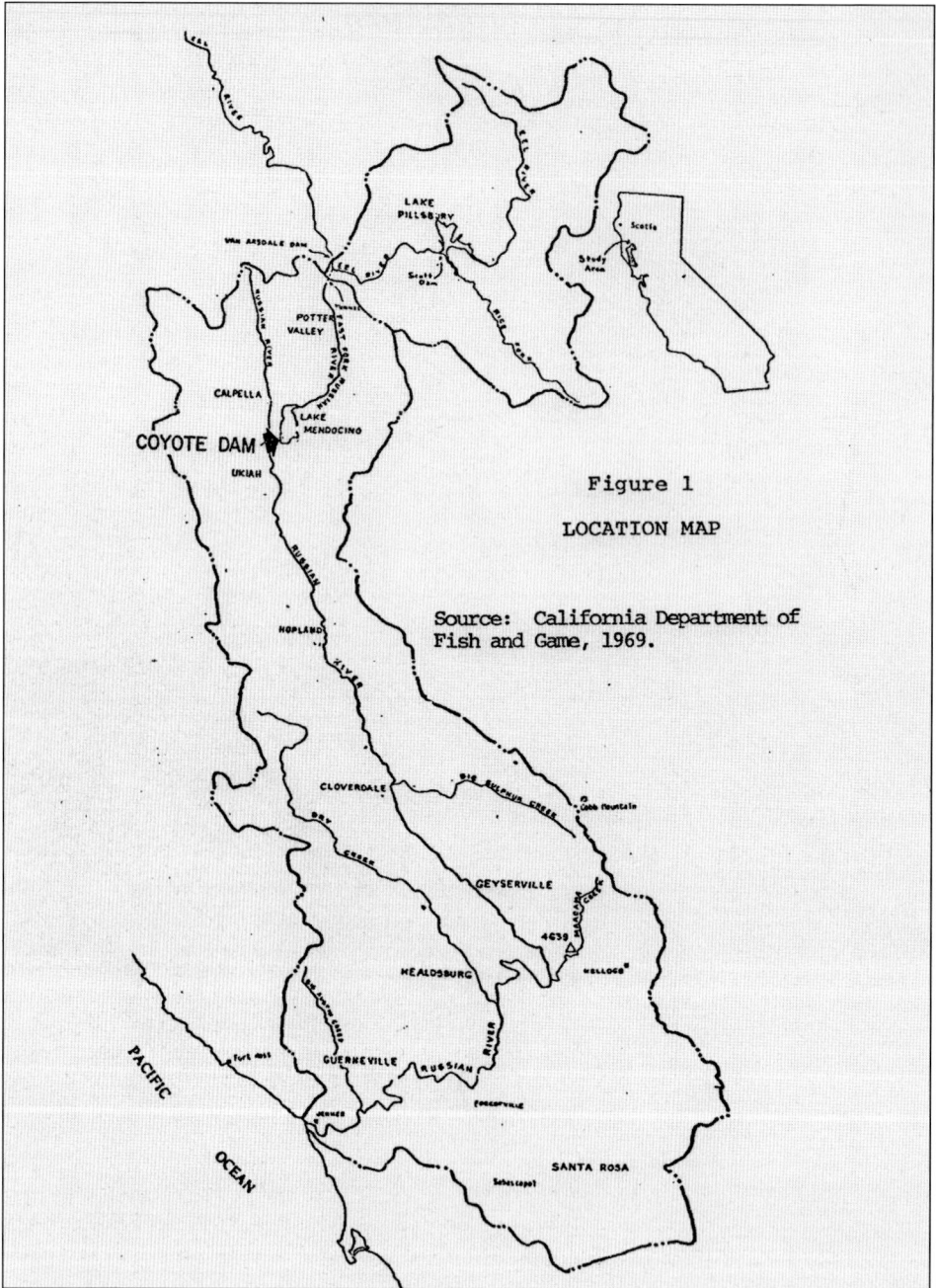

Figure 1

LOCATION MAP

Source: California Department of Fish and Game, 1969.

The 1,485-square-mile Russian River watershed ranges from its headwaters in Potter Valley to the estuary and mouth at Jenner. On February 5, 2014, during the writing of this book, a ban was put on fishing the Russian for the first time in history. The California Fish and Game Commission voted unanimously to shut down the Russian River to fishing in hopes of creating more favorable conditions for at-risk salmon and steelhead. The decision, supported by anglers and conservationists, followed a year of record drought and a recommendation made by the California Department of Fish and Wildlife. It remains to be seen if this was a case of "too little, too late" or "never too late." (Courtesy of California Department of Fish and Wildlife.)

This 1867 Sonoma County map drawn by A.B. Bowers—a surveyor, topographer, and draughtsman—displays the lower Russian River watershed when the Mexican land grants were being put into place. The map prominently displays the estuaries so essential for salmonids during the transition from fresh to salt water and back again. Jenner by the Sea, Penny Island, and the mouth of the river are all on the left side of the map. Numerous sawmills dot the landscape, and their accompanying railroads traverse the land. Railroad transportation allowed industrial expansion into landscapes that were once remote and wild. This map records an era of unregulated harvesting of Sonoma County's resources. Wetlands, conifer forests, rivers, grasslands, and oak woodlands all suffered under the idea of growth no matter what the cost. Today, the Russian River bears the scars, some of which have yet to fully heal, of many decisions made during this time of exploitation. (Courtesy of Harry Lapham.)

13

Archived photos of the Russian River offer a historical perspective of the river in the last 100 years. This photograph shows the Russian one mile from Ukiah at the north end of the river's watershed. (Courtesy of Mendocino County Museum.)

This panoramic view of the Russian River looks west from the backside of Fitch Mountain toward Healdsburg. A deep river hole near Fitch Mountain Tavern was a productive and prolific fishing spot. (Courtesy of Healdsburg Museum and Historical Society.)

The Laguna de Santa Rosa, one of the largest tributaries of the Russian River, has a watershed that drains over 250 square miles. The main stem of the Laguna stretches 22 miles from Cotati to its confluence with the Russian in Forestville. Pomo, Wappo, and Miwok peoples lived in the Laguna watershed for more than 10,000 years. As seasonal gatherers, they thrived on acorns, roots, seeds, berries, fish, coastal shellfish, waterfowl, and a variety of animals. They fashioned canoes, shelter, and rope from tule; wove fine, watertight baskets from willow and sedge; and harvested numerous plants for food, clothing, dyes, and medicines. After 1833 and the first Mexican land grant, the character of the Laguna changed dramatically. Early settlers cleared oak woodlands to make way for grain, row crops, orchards, and hops. Developers built resorts for recreation along its shores. Boating the Laguna (pictured) became a favorite pastime. The 20th century saw an increase in land use as residential and commercial enterprises expanded into the upper watershed. By 1990, 92 percent of the Laguna's riparian forest was gone. (Courtesy of Harry Lapham.)

As the river heads south and west, it flows through the town of Guerneville and under the Guerneville Bridge near the popular fishing hole at Johnson's Beach. Guerneville, founded in the 1850s by the Guerne family, was once called Stumptown for its extensive clear-cut redwood and fir forests. Local lore states that it once had the greatest biomass density on the planet because of its big trees. Guerneville Bridge's beauty—in the daylight or moonlight—offers a reason why it was one of the most popular tourist destinations along the Russian River in the 1930s. (Both, courtesy of Western Sonoma County Historical Society.)

Dam and Bridge at Guerneville, Cal.

This 1953 hand-colored postcard shows the Guerneville railroad bridge in the background. The dam in the foreground demonstrates the extent of manipulation of the Russian River for recreational purposes. Many of the river's dams were temporary—constructed at the beginning of summer to create lakes or swimming holes and deconstructed before the first heavy rains of fall. (Courtesy of Western Sonoma County Historical Society.)

SCENE FROM BRIDGE AT GUERNEWOOD PARK

This meandering tributary of the Russian River at Guernewood Park, one mile west of Guerneville, shows the gravel substrate needed for steelhead and coho to build their nests, or redds. Abundant riparian vegetation shading the water keeps the temperature cool and, in some places, provides woody debris habitat that offers protection from predation. (Courtesy of Western Sonoma County Historical Society.)

Both of these photographs were taken in 1917 from the River View Hotel. The above photograph offers a detailed view of the railroad bridge that carried freight and passengers from the Dutch Bill watershed along what is now known as the Bohemian Highway. The narrow gauge railroad was first developed to haul lumber from nearby hills to the Russian River for transport to ocean freighters or Santa Rosa. The railroad soon took advantage of the booming tourism industry and also carried tourists from San Francisco. The below photograph shows the north side of the Monte Rio beach filled with bathers. Note the forest (on the hillsides in the background) that has been clear-cut for timber harvest and housing developments. (Both, courtesy of Harry Lapham.)

Jenner, a small town on the mouth of the Russian River, was originally part of the Rancho Muniz. In 1867, Charles Jenner built a house at Jenner Gulch, which sits at the center of the town, which has a population of less than 200. The town maintained its population through the early 20th century, when a sawmill and camp were established for the timber trade. Today, tourists pour into Jenner to kayak the estuary; salmon and steelhead use estuaries to adapt to briny conditions before entering the ocean and to adapt to fresh water before migrating upstream to spawning areas. Because the Russian River now has a higher flow due to the Eel River diversion, the estuary sandbar has regularly been forcibly breached to prevent flooding. Now that humans have a better understanding of the needs of salmonids, reducing summer flows in the Russian reduces the number of times the sandbar is artificially breached and may improve summer fish habitat by allowing the formation of a freshwater lagoon. (Courtesy of Harry Lapham.)

The ferry at Jenner, located above the confluence of Willow Creek and the Russian River, provided the only transport across the lower river before the construction of Highway 1. The above image looks west. Barely visible in the center background is the construction of the Highway 1 bridge at Bridgehaven. Once the bridge was completed, it rendered the ferry unnecessary. Alex Cuthill offered his services as ferryman to transport both people and livestock. There was no fare for using the ferry, because the county operated it as a public service. Cuthill ran the ferry every day from 1918 to 1931. In the 1919 photograph below, the wagon carries a cart of tanbark to be loaded onto railroad flatcars. The wagon and horse team belonged to Louis Sonoma Beedle. (Above, courtesy of Western Sonoma County Historical Society; below, courtesy of Fort Ross Conservancy.)

Chas. Peck,

In the 1920s, hundreds of people gathered for the opening day of the first bridge to span the Russian River near its mouth. The bridge heralded a changing time for the Russian River area, as tourists and individuals could visit without the need for railroad travel. (Courtesy of Healdsburg Museum and Historical Society.)

This photograph shows where the Russian River meets the Pacific Ocean. An old concrete jetty is visible in the center. In the early 1930s, a series of private companies built a jetty at the mouth to keep the river open for shipping. They added material over the next two decades, but the effort was abandoned when the jetty's purpose failed. (Courtesy of King's Sport and Tackle.)

Icene lion marin de la Californie

In the past and the present, biodiversity abounds in the Russian River watershed. Russian artist and explorer Louis Andreyevich Choris recorded many California species in *Voyage Pittoresque Autour de Monde*, a portfolio of his images published in Paris in 1822. In 1816, he drew a California sea lion (above), some of which made their way into the Russian River to feed off the migrating salmon as they returned to their natal tributaries for spawning. The grizzly bear portrait below hints at the story of what was once a seemingly inexhaustible species in California. Due to overhunting, the only place the grizzly survives in California is on the state's flag. Perhaps people, having learned from stories like that of the grizzly, will help heal the salmonid populations before they, too, become extinct. (Both, courtesy of Fort Ross Conservancy.)

L'Ours gris de l'Amérique Septentrionale
(Ursus griseus cuv.)

The Russian River, in addition to its mammalian and avian diversity, was once known among anglers as the most productive steelhead fishery in the state. To successfully survive and make it through the next century, steelhead need gravel-bottomed streambeds for spawning and protection of eggs, deep cold pools for fry to escape from predation, and moving water to ensure plenty of dissolved oxygen. In this photograph, taken at Mill Creek near Healdsburg, a steelhead jumps the falls on its way upstream. Note the deep pool below the falls, which gives the steelhead enough room to gain the momentum it needs to make the stupendous jump to continue its journey. (Courtesy of Healdsburg Museum and Historical Society.)

The climate of Sonoma County and the Russian River ranges between that of temperate rainforest and the Mediterranean. Each summer, the county faces seasonal drought; each winter, rain typically falls in abundance. The periods of heavy rainfall can and have caused enormous flooding. As wetlands, such as the Laguna de Santa Rosa, are lost due to human development, floods become more severe each year. The Laguna acts as a huge natural reservoir that can result in a 14-foot reduction in floodwater heights in the city of Guerneville. The Garibaldi Hotel in Guerneville is shown above during the great flood of 1906. Below, a massive storm in January 1995 flooded the Russian River, and her banks blanketed much of Guerneville in water. (Above, courtesy of Western Sonoma County Historical Society; below, courtesy of King's Sport and Tackle.)

As industry flourished in Sonoma County, so did the number of weekend visitors coming from Bay Area cities. To draw visitors to Russian River resorts, communities installed temporary dams, such as the one in this 1915 image, to create short-term reservoirs used for swimming and boating. (Courtesy of Sonoma County Library.)

Vacation Beach Dam, the most downstream dam along the Russian River, is approximately two miles west of the Johnson's Beach Dam in Guerneville. Though the dams are dismantled in October, ideally before the chinook migration, they change the character of the river by warming and slowing the water, which destroys the deep, cold pools necessary for the survival of young anadromous fish. (Courtesy of Sonoma County Library.)

Dr. Burke's Medical and Surgical Sanitarium
Source: Reynolds & Proctor, Illustrated
Atlas of Sonoma County, 1898.

The Russian River's flow has also been changed by man-made diversions. Although this 1898 photograph was taken outside of the Russian River watershed, this flume furnishing water to Dr. Burke's Sanatorium shows a typical diversion. Flumes are channels that divert water from the river to a destination. Diversions often lead to dry creeks and habitat loss. (Courtesy of Harry Lapham.)

As industry grew in Sonoma and Mendocino Counties, companies diverted water from river sources and transported it to drier areas. This photograph portrays the Snow Mountain Water and Power Pipeline north of Ukiah. Note the erosion and sediment load that will wash into the streambed below with the next rain. This photograph was taken by A.O. Carpenter. (Courtesy of Grace Hudson Museum and Sun House.)

Though wine grapes were first brought to the area by Russian settlers in the early 1800s, the winemaking industry did not really launch until the 1850s, when irrigation became legal. The unquenchable thirst of miners, lured by the gold rush, helped make grape-growing one of the most profitable ventures in the region; it is still lucrative today. The image above shows the Rodney Strong Vineyards on Old Redwood Highway along the Russian River. The photograph below was taken on April 10, 1873, and shows Dr. Ely's vineyards near Geyserville. Vineyards take a toll on steelhead and salmon by depleting water levels in dry summer months, adding sediment into the streambeds, and increasing the river's levels of toxins from pesticides and herbicides. (Above, courtesy of Sonoma Library; below, courtesy of Healdsburg Museum and Historical Society.)

Along with the boom in vineyards, Sonoma County became an agricultural mecca in the early 20th century, providing wheat, apples, pears, cherries, and prunes to feed residents of the growing Bay Area and to feed the continual stream of miners. This, coupled with the land cleared in successful logging campaigns, brought new challenges to the Russian River watershed. In the above photograph, a steam-powered thresher and crew work on separating chaff from grain during a harvest. In the photograph below, a team mowing after the harvest demonstrates the prevalence of wheat farming along the Russian River. (Above, courtesy of Harry Lapham Emery Escola Collection; below, courtesy of Mendocino County Museum.)

Hops came to Sonoma in the 1870s, and by 1889, Sonoma County led the world in hops production, all thanks to water from the Russian River. Although the hops industry was diminished by the 1960s due to Prohibition and downy mildew, it had a profound effect on the Russian River both physically and culturally, as shown in this Parkins Collection photograph. (Courtesy of Mendocino County Museum.)

This September 1939 image shows unidentified men at harvest time in the pear orchards of Dutton Ranch, located in Ukiah Valley near the Russian River. Farmers in Ukiah Valley, which has been an agricultural area for over 150 years, currently grow pears and grapes—the only two crops that can be legally irrigated today. (Courtesy of Mendocino County Museum.)

As land was cleared by loggers, grazing—along with agriculture—became a lucrative business in the Russian River Valley. Livestock inundated the clear-cut hillsides. By 1880, three million cattle and six million sheep were grazing upon California's open spaces and grasslands. Grazing practices used at this Anderson Valley Ranch (pictured) in the upper Russian River watershed continued the destruction of the watershed by increasing erosion and incision of small tributaries. The above photograph is from the Emery Escola Collection. The below photograph shows a sheep-shearing operation in Potter Valley near the headwaters of the Russian. Cattle and sheep ranching added to the denuding of vegetation, the loss of plant biodiversity, and the lack of riparian vegetation necessary for healthy fish habitat. (Above, courtesy of Mendocino County Museum; below, courtesy of Harry Lapham.)

30

Gravel extraction from the Russian River's channel, gravel bars, and floodplains has occurred since 1900 to supply aggregate for asphalt. Starting in 1940, the volume of mining greatly increased to accommodate the growing Bay Area population. Until 1980, there was almost no regulation of gravel-mining practices such as digging deep pits in the middle of the Russian River, and unregulated mining led to incision of the river channel. In some areas, the channel bottom dropped more than 25 feet, leading to bank erosion and reduction in habitat complexity. Additionally, incision cut into tributaries, which created fish passage problems. This 1937 image shows the Basalt Rock Company, which was located along the Russian. (Courtesy of Healdsburg Museum and Historical Society.)

Excessive mining caused the Russian River to be cut off from floodplains and reduced the amount of streamside (or riparian) vegetation critical to salmon and other wildlife species. The changes in the channel bed also led to the scouring of gravels used by salmon for spawning and greatly reduced the habitat for these economically and culturally important fish. Other impacts included changes that have lowered floodplain groundwater levels, forcing well owners to have to drill deeper to access water. In this 1965 photograph, Basalt Rock Company's earthmovers have been moved to higher ground to avoid the Russian River's winter floods. (Courtesy of Healdsburg Museum and Historical Society.)

Massive development for recreation in the Russian River Valley has also changed the character of the watershed. Man-made infrastructure—such as dams, roads, and diversions built to accommodate thousands of tourists—has taken a toll. Here, bathers and boaters enjoy the Guernewood Park swimming hole near Guerneville. (Courtesy of Western Sonoma County Historical Society.)

Though tourists first came with the railroads in the late 1800s, they continue to flock to Sonoma County and impact the watershed and its fish. Each year, more than 7.4 million tourists come to the area and spend up to $1 billion—much of it along the Russian River. (Courtesy of Western Sonoma County Historical Society.)

Starting in the early 1900s, the Healdsburg Water Carnival took place every summer near Memorial Beach in Healdsburg. This old-time parade of whimsical, funny, and creative watercraft tells a tale of the eclectic residents of the Russian River Valley and shares a story of the many recreational uses of the Russian River. Though the Russian River community rallies behind the return of the salmon, it is hard-pressed to release the dams that have provided summer entertainment for so long. To celebrate its roots, the Healdsburg community has revived this festive parade. (Both, courtesy of Harry Lapham.)

Two

THE POMO

For more than 10,000 years, different bands of native people lived in what is now known as the Russian River watershed. European settlers, upon arriving in the area, grouped these people into one tribe they called Pomo, although the languages of the various native groups differed dramatically. They spoke distinct tongues, but their practices on the land and river shared similarities. Native Californians tended to live a slower life, working for sustenance only a few hours each day, because of the abundant food sources and the mild weather of the watershed. Men hunted elk and deer, while women collected wild plants that were used to provide a majority of the food.

The river supplied a continuous stream of material for practical and edible goods. Fish, waterfowl, and numerous invertebrates supplied food as well as resources for basket-making, artistry, and ceremony. Baskets from the Pomo culture have been heralded as the most sophisticated basketry in North America. The baskets, made from plants that grow along the riverbanks, are highly prized for their cultural significance and historical relevance.

Seasonally, men, women, children, and elders visited the river to harvest steelhead and salmon during migration. The Pomo used multiple techniques to catch the fish: toggle harpoons; botanical fish poisons; dip, thrust, arch, and A-frame nets; basket traps; and fish weirs. In spring, when the river flows were low but the fish were still migrating, communities built dams (weirs) to catch fish moving upstream.

Men constructed dams in a narrow channel of the river, just upstream of a large pool, while women and children collected materials. The willow-woven dam, once constructed, formed a V-shape pointing upstream, and men, women, and children drove fish into a conical fish trap in the center. Each fishing foray ended with celebration and ceremony to safeguard man's relationship with the river and fish.

Though the salmon runs are depleted, the Pomo still practice similar ceremonies today to honor humanity's partnership with nature.

While exploring the California coast, Russian Louis Andreyevich Choris, upon early contact with California natives, sketched their diverse faces. Choris caught a moment in time before native culture was decimated by disease and missionary dogma. He took great interest in the Pomo people and featured them in his portfolio collection, *Voyage Pittoresque Autour de Monde*, published in Paris in 1822. (Courtesy of Fort Ross Conservancy.)

The Pomo people lived in accordance with their natural surroundings. Here, a Pomo man hunts deer by taking on the stance and behavior of his quarry. To be successful, he must fully understand his prey and thus honors the animal before killing it. (Courtesy of Fort Ross Conservancy.)

36

Pomo people deeply understood the natural resources provided by the river and depended on it for food, materials, and housing. The 1922 photograph above depicts summer homes made from tule, an essential rush that grows along the banks of the Russian River. Artist Grace Carpenter Hudson is seated behind the Pomo woman at right. The image below, titled "Things of the Indians in California," was included by artist Louis Andreyevich Choris in his portfolio collection, *Voyage Pittoresque Autour de Monde*, and portrays the relationship between the Pomo and the natural world. It also tells a story of the importance of basketry to the Pomo. The Pomo created watertight baskets for multiple uses. Because of intermarrying, many Pomo travelled to St. Petersburg when the Russians left Fort Ross in 1841. Today, the Kunstkamera museum in St. Petersburg holds the largest Pomo basket collection in the world. (Above, photograph by H.W. Henshaw, courtesy of Healdsburg Museum and Historical Society; below, courtesy of Fort Ross Conservancy.)

Pomo baskets are beautiful and utilitarian. The above photograph displays a papoose, fish traps, a seed beater, and other baskets from the John W. Hudson Collection. The large object in the center is a fish trap used during communal fish harvests. The trap consists of an outside cone and a shallower inner cone with an opening in the center. Fish could easily enter but had a hard time leaving. A fish-carrying net is shown below. Though not all baskets were used for riverine activities, most of the materials for baskets come from riparian vegetation, such as willow and sedge, on the banks of the water. The practical values of the river stretched far beyond the immediate harvest and into cultural life. (Both, courtesy of Healdsburg Museum and Historical Society.)

This Pomo elder displays her profound basket-making abilities. The darker shades of this basket were most likely from sedge roots growing along the wet banks of the river and tributaries. As earning a living became more and more difficult, many Pomo women created baskets to sell to the public. This photograph is part of the Aginsky Collection. (Courtesy of Mendocino County Museum.)

This young Pomo girl holds a finished basket in her left hand and an unfinished basket in her right hand. Inside the unfinished basket are materials for completion. To maintain the tribe's stories, plant knowledge, and relationship with the land, elders passed down basket-making skills to their kin. This photograph is part of the Aginsky Collection. (Courtesy of Mendocino County Museum.)

Pomo Indian Dancers and Fire Eaters Lakeport, California

Dance and ceremony were and are essential practices of the Pomo people. The Pomo regard natural resources in partnership with humans, be it basket-making materials or fish for sustenance. They considered salmon as having spiritual powers, and their ceremonies aligned humans in a rightful relationship to plants and animals. Without this ceremony, the salmon might be offended and remain aloof. Early salmon and communal dam-building ceremonies arose from the need to carefully manage anadromous fish populations. While the ceremony was in effect, no tribe members could fish without tribal permission. Once the ritual was over, fishing bans were lifted, which likely ensured that fish resources were available to all members of the village. The bans also may have ensured that the salmon run was well underway, allowing enough salmon to be able to reach spawning grounds before being caught. Pomo regalia for these ceremonies also depended upon resources provided by the Russian River watershed—waterfowl and forest birds for feathers, deer and elk for hides, and marsh plants for cordage. This photograph is part of the Aginsky Collection. (Courtesy of Mendocino County Museum.)

In the early 1800s, European exploration flourished in California, and fur trapping, land expansion, and Christian missionaries moved into California and Sonoma County. The Russians, already present in the Pacific Northwest, began to move southward after decimating northwestern sea otter populations for the animal's pelts. The Russian-American Company (a trading company) established Fort Ross in 1812 on the coast 80 miles north of San Francisco. Ten miles north of the mouth of the Russian River, 25 Russians and 80 Alaskan Aleuts occupied the fort with the intention of trapping animals for fur and growing food to transport to their Alaskan settlements. This image of Fort Ross was drawn by August Bernard Duhat-Cilly in July 1828. High-ranking officials and visitors stayed inside the fort's walls. The Russian and Creole employees lived in the houses west of the walls, while the Aleuts and Pomo lived separately in a village to the south. (Courtesy of Fort Ross Conservancy.)

Unlike the missionaries, the Russians had little interest in religious conversion, and Fort Ross became a tricultural community where Aleuts, Pomos, and Russians lived in mutual tolerance. Since there were few women among the Russian colonists, the men often married native women. This drawing depicts Pomo life near Fort Ross. Henry Raschen created this painting, titled *Indian Camp Near Fort Ross*, in the 1880s. (Courtesy of Fort Ross Conservancy.)

For over 30 years, Russians and Native Americans lived in close proximity and shared cultural traits. Intermarrying became a common occurrence. The children of these unions were known as Creoles. In 1836, a total of 260 people lived at Fort Ross. There were 120 Russians, 51 Creoles, 50 Kodiak Aleuts, and 39 baptized Native Americans. I.G. Vozensenskii drew this portrait of a Creole in 1841. (Courtesy of Fort Ross Conservancy.)

The two most northern Californian missions baptized over 600 Pomo people, who were made to conform to a rigid Christian life. Songs, languages, ceremonies, and practices that maintained relationships with nature and community became illegal and were forced underground. Many Pomo forgot the salmon ceremonies. This sketch by Louis Andreyevich Choris was included in *Voyage Pittoresque Autour de Monde.* (Courtesy of Fort Ross Conservancy.)

The Fort Ross church and ranch is shown here in 1905, nearly 65 years after the Russians left California. Some Pomo immigrated to Russia with their spouses, but most turned to a lifestyle of hourly wages as subsistence living became more difficult after the encroachment of white settlers. This photograph is from the Emery Escola Collection. (Courtesy of Mendocino County Museum.)

Early nonnative settlers pushed Native Californians from their ancestral lands until all that the natives retained was a miniscule portion of the land they once hunted and stewarded. The Pomo were no longer able to participate in practices that had allowed abundant survival for millennia. Instead, the land was used for agriculture, timbering, homesteading, or development, and the Pomo were forced to earn wages to buy food. In this photograph from the Parkins Collection, the Pomo weigh their hop harvest at the end of a day. Hops are the female flower of the hop plant. (Courtesy of Mendocino County Museum.)

From the 1870s to the 1950s, hops were one of the main cash crops in Sonoma County. A single 80-acre hop yard required the labor of more than 1,000 people and took more than two weeks to harvest. Many Pomo people, along with their families, began working in hop fields in order to survive, as demonstrated by the Pomo women in the image at left. (Courtesy of Western Sonoma County Historical Society.)

In this 1940 photograph from the Parsell Collection, master basket-maker and Dreamer elder Elsie Allen (right), and Lorrain Lockhart show the uses of a basket at the Pomo Mother's Club in Ukiah. The Pomo Mother's Club, led by Allen, Annie Burke, and Edna Sloan Guerro, had a mission to support the community through education and fundraising. "The members organized dances and bazaars, selling items that had been donated or handmade by club members. If someone fell on hard times and needed money for funeral expenses or because of illness, unemployment or other unexpected hardship, the club stepped in . . . At the time the [club] was founded, prejudice against Indians was widespread, especially in the Ukiah area," Edna Guerro recalled in *First Families: A Photographic History of California Indians*, by L. Frank and Kim Hogeland. "Beauty shops, barbershops, wouldn't allow Indians. The only restaurant that allowed us to come in and eat was owned by the Chinese. We weren't even permitted in the toilets." (Courtesy of Mendocino County Museum.)

Lorrain Lockhart (right) and Annie Burke demonstrate the practical uses of baskets at the Pomo Mother's Club in this image from the Parsell Collection. These women and the club offered a refuge for Native Californians who had been demoralized and defeated. The women felt that the best way to fight racism was by educating nonnatives, especially by spotlighting native basketry. (Courtesy of Mendocino County Museum.)

Maude Knight, of the Yokayo Rancheria, is making a basket in this image. Ukiah derives its name from the Pomo word *Yo-kayo*, meaning "deep valley." Pomo women also earned money by making baskets for tourists; discrimination against natives offered little opportunity for other work. This photograph is from the Parsell Collection. (Courtesy of Mendocino County Museum.)

Three

THE FISH AND THOSE WHO CATCH THEM

For many millennia, the Russian River has been home to more than 50 species of fish ranging from the ancient Pacific lamprey to the culturally significant salmon. Both native and nonnative fish depend on the river's warm and cold waters to find sustenance, seek refuge, and spawn.

In the fall, California's Mediterranean climate brings rain and heralds the return of anadromous fish. As early as September and through December, the endangered chinook salmon (*Oncorhynchus tshawytscha*) arrive. Steelhead trout (*Oncorhynchus mykiss*), also endangered, follow in November. With the steelhead come the endangered coho salmon (*Oncorhynchus kisutch*). Year-round residents also thrive in the Russian River, including catfish, smallmouth and largemouth bass, and bluegills.

Other anadromous fish in the Russian include striped bass (*Micropterus punctulatus*), American shad (*Alosa sapidissima*), Pacific lamprey (*Entosphenus tridentate*), and white sturgeon (*Acipenser transmontanus*). In the early 1820s, Russian explorer K.T. Khlebnikov noted in his journal that an expedition sent up the Slavyanka River returned with two white sturgeons, including one that exceeded a length of "two arshins" (4.67 feet). As the largest freshwater fish in North America, incredibly, white sturgeons still inhabit the Russian River.

Sadly, dramatic decreases in steelhead, chinook, and coho populations reflect the negative effects of human development. Since it is illegal to catch wild steelhead, hatcheries clip the adipose fin of all farm-raised steelhead so that anglers can tell the difference. A strict no-take policy exists for the chinook and coho; if these fish are mistakenly hooked while fishing for hatchery steelhead, the fisher must immediately release the fish so they have a chance to replenish the species.

Thankfully, anglers are some of the biggest advocates for the salmon and steelhead. Volunteers, like those who founded the Russian River Wild Steelhead Society, spend countless unpaid hours working to aid to the return of salmonids to the Russian. Policy alone will not save these fish—it will take the mindfulness, passion, and commitment of people like the anglers to turn the tide of this story.

Prior to the arrival of nonnative settlers, development, and industry, Sonoma and Mendocino were prolific and productive fisheries. After the outsiders arrived, fishermen harvested huge unregulated bounties of chinook, also known as king salmon, off the coast and from rivers. This Wonacott Collection photograph of a fish plant in Mendocino County offers an idea of the massive daily catches. (Courtesy of Mendocino County Museum.)

According to the caption in *The Mendocino Coast: A Pictorial History, Volume II:* "'Little Phil' poses with 15 fish, apparently caught with the hand line wrapped around his hand . . . he was arrested several times in the early 1900s and charged with netting salmon . . . a number of men were arrested for gill netting salmon . . . but few were convicted." The practice of gill netting contributed to the overfishing of salmon and depletion of the fisheries. This photograph is from the Wonacott Collection. (Courtesy of Mendocino County Museum.)

Fishing on the Russian River was not only for men. In May 1909, Blanche Riddell (left), her aunt Mary Harmon (center), and Mary's daughter Dorothy spent a day on the shores of the Russian. These women are the descendants of Otis and Harriet Allen. (Courtesy of Western Sonoma County Historical Society.)

The relationship to the Russian River runs deeply though generations of locals. This photograph was donated by Gina Casini, the fourth generation of six Casini generations to live along the river. Gina learned her riverine mastery from her father and grandfathers and holds memories of changes in the area's topography, policy, and fish populations. (Courtesy of the Casini family.)

Gina Casini recalled how her family ranch near Duncan's Mill was a gathering place for the "old timers" after a day of fishing. Though she did not realize the significance when she was a child sitting with famous anglers, she now laments the bygone era when people relaxed and joined together to share stories over fish, hunting, or politics. (Courtesy of the Casini family.)

While anglers gathered to tell fish tales of the day, they also expressed sadness that large morning catches, like the one in this photograph taken by A.O. Carpenter, were a thing of the past. These trout were taken out of the Russian River in just a few early hours at dawn. (Courtesy of Grace Hudson Museum and Sun House.)

This photograph's caption reads: "A Morning's Catch at Fitch Mountain Tavern—Russian River near Healdsburg, Cal." There were abundant fishing holes along the Russian; fishers commonly took enormous steelheads from its waters until the 1970s, when the fishery began to collapse. (Courtesy of Sonoma County Library.)

During the annual Russian River Steelhead Derby, Lloyd Herling of Guerneville pulled two nine-pound salmonids (a steelhead and a chinook) from the river at Duncan's Bridge. Holes near Duncan's Mills offer some of the best fishing, as they provide the first resting place for migrating steelheads as they swim upstream from the ocean. (Courtesy of King's Sport and Tackle.)

In this image from the Parkins Collection, spearfisher Charles Babakas searches for his quarry—most likely salmon, but possibly frogs or lamprey. Spearfishing is as old as the Pomo, who not only used communal dams and nets but were also successful with spears. Note the railroad tunnel in the background; even the most remote streams were permeated with man-made development. (Courtesy of Mendocino County Museum.)

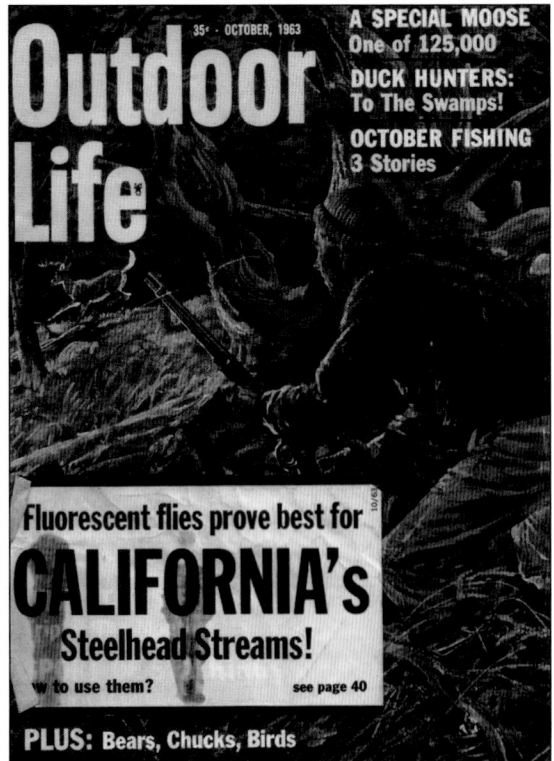

Spears, nets, and tackle were only some of the techniques used to capture salmon and steelhead running upstream. Purists believe the only true way to catch a fish is with flies. This October 1963 edition of *Outdoor Life* proclaims new innovations for flies and what works best. (Courtesy of the Casini family.)

In the mid-20th century, the steelhead migrations were prolific and ran the river predictably and annually. From December through early spring, anglers stood shoulder-to-shoulder on the Russian River near Healdsburg to harvest the bounty of the first run of the year. (Courtesy of Healdsburg Museum and Historical Society.)

Crowds of anglers flocked to temporary summer dams to take part in the early chinook migrations. Chinook would rest and gather strength in the pools below the dams before jumping over the dams. Anglers, knowing the fish like the backs of their own hands, used their knowledge of this behavior to harvest that night's supper. (Courtesy of the Casini family.)

Dry Creek Pomo elder Reg Elgin shared a memory told to him by his aunt: "She remembered times regularly, several times a year, when the fish would come in. The creek would seem to run red with the color of salmon. You could walk across the creek, without getting wet, on the backs of fish." The recollection of memories like this helps modern anglers to understand photographs like these in which anglers fished side by side, lines tangling and boats bumping. There was clearly a time when the Russian River contained enough fish for everyone. (Both, courtesy of the Casini family.)

King's News and Tackle (now King's Sport and Tackle), opened by Grant King in Guerneville, has supplied anglers with fishing gear, guides, and bait for more than 50 years. This iconic business provides something more, though; old timers, newcomers, and those in-between all gather here to learn about and share stories of their days. King's, which serves as a kind of historical fishing archive, offers something akin to the gatherings that occurred at Casini Ranch. Steve Jackson, the current owner of King's, ensures that the legacy continues. The above photograph shows the interior of the store in its early days. The below photograph shows King's News and Tackle under a blanket of snow on January 3, 1974. (Both, courtesy of King's Sport and Tackle.)

Grant King, owner of King's Sport and Tackle, poses with a steelhead. According to the documentary *Rivers of a Lost Coast*, "Grant King, the Russian River fly shop owner, was famous for 'holding court.' Quick to share a cup of coffee or pour a drink, Grant loved to ramble with his fellow anglers. In the 1950s, a key element to the allure of the Russian River was a stop at King's News and Tackle. Grant was a prolific fly-tier who, over his 40-year career, created dozens of original patterns. Today, he is best remembered for refining Virgil Sullivan's Boss Fly—a classic American pattern. As much as King's News and Tackle was a selling point for the Russian River, so too was the legend of Bill Schaadt. During the 1950s, Grant's enthusiastic stories helped proliferate the amazing antics and accomplishments of the elusive angler." (Courtesy of King's Sport and Tackle.)

Bill Schaadt (1924–1995) is perhaps one of the most famous fly fisherman along the Russian River—with the most infamous reputation. His infamy, and most likely his success as an angler, comes from his fishing obsession. This quote from Ken Schultz sums it up: "He does not quit—in fact, he does not even stop to eat—until it is too dark to see. It was once written that he rolled his car into the Eel River. He crawled out, dragging his fly rod with him, and hiked to the river. It was not until that night, the fishing over, that he summoned help to right his car." In the photograph at right, Schaadt holds a chinook. In the 1991 photograph below, Schaadt is fishing the Russian at Northwood. (Right, courtesy of the Casini family; below, courtesy of King's Sport and Tackle.)

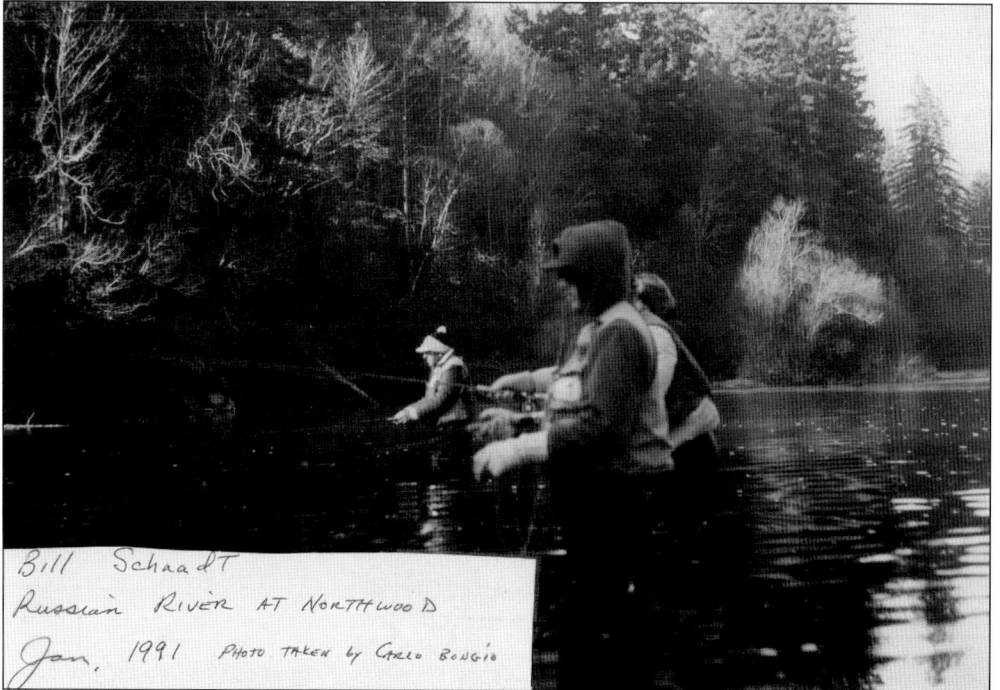

Bill Schaadt
Russian River at Northwood
Jan. 1991 Photo taken by Carlo Bongio

57

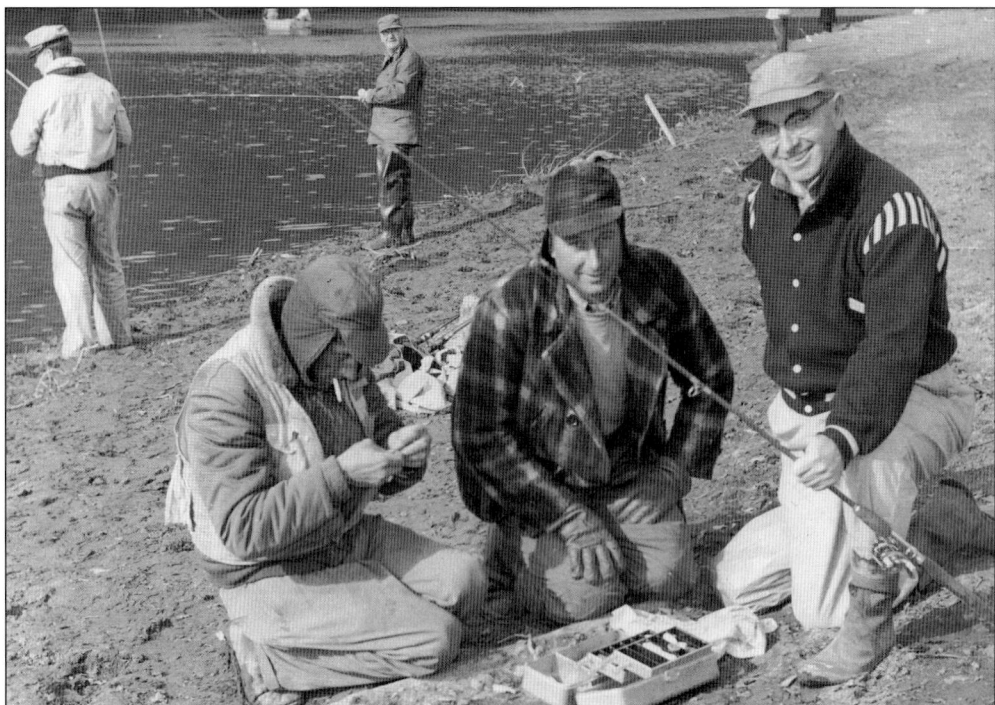

Bill Schaadt (left) sits with his friend George Casini (center) and an unknown angler on the banks of the Russian River. Gina Casini, George's daughter, remembers sitting at the kitchen table when Schaadt told her family he was dying from cancer. By the time he died in 1995 at age 71, Schaadt's life had been filled with his work as an artist, sign painter, collector, and, in some circles, the most famous fly fisherman in the world. (Courtesy of the Casini family.)

George Casini sits in front of his morning catch. In the same kitchen where Schaadt once sat, Gina Casini and fisherman Bruce MacDonell now wonder where the fish went. She asks, "Where are the stripers? The catfish and the bluegill are gone." (Courtesy of the Casini family.)

Earl Crawford, like Bill Schaadt, has taken his place amongst the legends of fly fishermen along the Russian River. He is perhaps most well known for taking two sturgeons out of the river, both of which weighed more than 100 pounds. Photographs of Crawford with these enormous fish are celebrated along the river. Local Bruce MacDonell shared that he used to stare at the photograph in wonderment. Would he one day catch such a fish? The image at right shows Crawford (right) with an unknown fishing buddy. In the advertisement below, Crawford offers his services for just $15 per day. Today, guided tours on the Russian River cost $200 or more. (Both, courtesy of the Casini family.)

GUARANTEE

~FISH~

OR NO PAY

Furnish Large Safe and Comfortable Boat and Bait.

I'll supply correct tackle if you haven't your own. Take you to the hot spots and handle boat all day. Any large Steelhead or Salmon landed during the day, you pay me $15.00 for two people.

This is your surest way to take fish home.

PLEASE MAKE RESERVATIONS IN ADVANCE.

Fourth-generation Russian River resident Bruce MacDonell began his fishing career when a morning's catch could easily consist of a half-dozen or more fish. In this early-1970s photograph, a young MacDonell carries home five steelheads after only a few hours on the river. (Courtesy of Bruce MacDonell.)

As a young adult, MacDonell counted on the Russian River to yield numerous fish. The species did not matter—bluegill, catfish, stripers; he ate them all. By the 1970s, MacDonell noticed his yield dwindling. He attributes the dearth to many factors, but suspects a 1982 formaldehyde spill near Healdsburg, after which the shores of the river stunk for days from decaying dead wildlife. "The river never rebounded from that," MacDonell says. (Courtesy of Bruce MacDonell.)

As fish populations dwindled in the Russian River, MacDonell's concern grew to a point at which he could no longer sit on his hands and watch the destruction of the river on which his grandfathers and children were raised. To address his concerns, MacDonell became the president of the Russian River Wild Steelhead Society (RRWSS). The society consists of dedicated individuals, focused on the restoration of the Russian River watershed, who work to preserve, protect, and enhance the wild steelhead through hands-on projects and education. Since its inception in 2009, the group has partnered with state and federal organizations to create healthy habitat for steelhead and coho. These photographs show MacDonell with a striped bass (above) and a chinook (below). (Both, courtesy of Bruce MacDonell.)

In 1998, after months of chasing, Bruce MacDonell caught a 91-inch-long white sturgeon at Hacienda Hole. In earlier attempts, the bony appendages that flank the sturgeon's sides cut the line. Once MacDonell finally hooked the behemoth, it took most of the day to land him. MacDonell speaks appreciatively of the fish's cunning. To escape capture, the sturgeon used underwater and partially submerged snags and roots to tangle the line. When MacDonell finally drew the fish to the surface, it took three men to lift the 230-pound creature. In the below photograph, MacDonell happily releases his quarry to honor its long life. Sadly, after MacDonell released this ancient fish, a tourist caught a smaller sturgeon—possibly the mate of MacDonell's fish—in the same hole and illegally killed it. (Above, courtesy of King's Sport and Tackle; below, courtesy of Bruce MacDonell.)

A fisher holds a white sturgeon that was captured in the Russian River. White sturgeons, the largest freshwater fish in North America, can weigh up to 1,500 pounds. It is believed that they have changed little since they first evolved 175 million years ago. These anadromous fish can live for over 100 years, reaching maturation by age 25. (Courtesy of King's Sport and Tackle.)

The prime time for catching catfish begins in early summer and goes through the end of the season. According to local anglers, even the catfish in the Russian are not nearly as prevalent as they were a few decades ago. This 16-pound catfish was caught in Lake Sonoma on March 28, 1997. (Courtesy of King's Sport and Tackle.)

Striped bass no longer abound in the river as they once did. Local Bruce MacDonell recalls that they once migrated up the streams to spawn, but now the only time he sees them is when they come into the river to feed on salmonid smolts swimming to the ocean. Perhaps the loss of habitat throughout the watershed also affects these anadromous fish. Bill Schaadt caught the stripers in the above image in 1974. Though these fish are abundant in the river during spring and summer, they are considered a major cause of mortality for chinook because they prey on juveniles in the main stem of the Russian River. In 1931, Merl A. Sturgeon brought home the 45-pound striper shown in the image at left. (Above, courtesy of King's Sport and Tackle; left, courtesy of Bob Sturgeon.)

Largemouth bass live best in warm, shallow waters. Dams along the Russian River create an ideal habitat for largemouth bass—warm, shallow waters with moderate clarity. These nonnative sport fish compete with native salmonids for prey, and once they have grown to five or six inches in length, they become primarily piscivorous (feeding on fish), going after salmonid fry and smolts. (Courtesy of King's Sport and Tackle.)

According to King's Sports and Tackle, "In April and May, another anadromous fish puts in an appearance—the small but mighty SHAD. What fighters these fish are! Mostly taken on flies and feathered lures, these fish provide a lot of entertainment as well as refining the fly fisherman's skill in using sinking shooting heads with wet flies." (Courtesy of King's Sport and Tackle.)

Dr. John Hudson moved to California from Tennessee in 1889 and became smitten with Grace Carpenter Davis, an acclaimed painter best known for her hundreds of portraits of local Pomo people. In 1890, they married, and both John and Grace advocated for the Pomo people and the natural history of the Russian River Valley. Though they traveled around the world, they made their home in Ukiah and spent their lives preserving and recording the stories of Native American life. (Courtesy of Grace Hudson Museum and Sun House.)

A.O. Carpenter, the photographer who took both of the pictures on this page, was Grace's father. This 1894 image shows Hudson with a 58.5-pound steelhead trout hooked from the Russian with a 7.75-ounce rod and No. 5 spook. (Courtesy of Grace Hudson Museum and Sun House.)

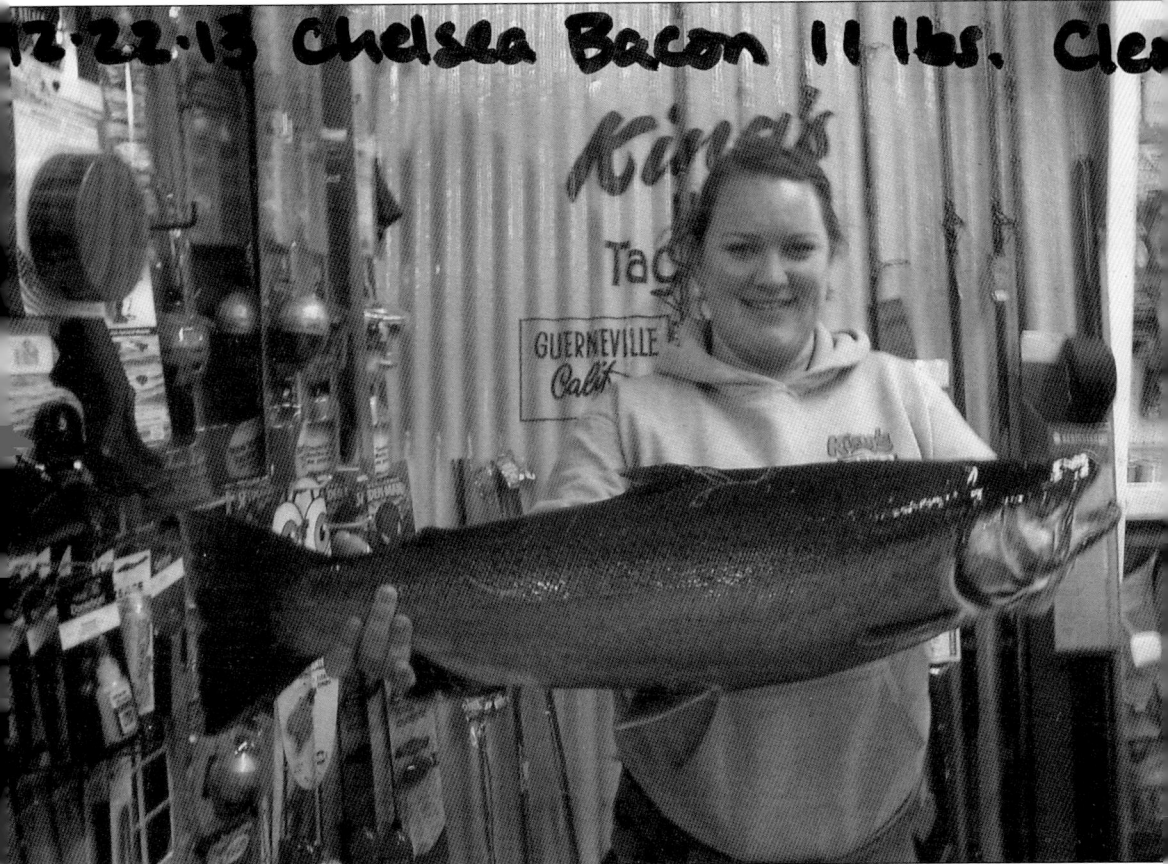

Chelsea Bacon caught this hatchery steelhead in December 2013. This 11-pound fish was pulled out of the Russian River using a cleo fishing lure. Steelhead are a unique species; individuals develop differently depending on their environment. While all steelheads hatch in gravel-bottomed, fast-flowing, well-oxygenated rivers and streams, some stay in fresh water for their entire lives—these freshwater steelhead are called rainbow trout. The steelhead that migrate to the ocean develop a slimmer profile, become more silvery in color, and typically grow much larger than rainbow trout that remain in fresh water. Steelhead are one of three salmonids (a taxonomic grouping including salmon, trout, char, freshwater whitefish, and graylings) that reside in the Russian River. These amazing fish begin their journey into the ocean at a length of four to eight inches. By the time they return to their natal tributaries, they have grown to around 23 to 30 inches in length and usually weigh between five and ten pounds. Unlike other Pacific salmonids, steelheads spawn more than once in their lifetimes. (Courtesy of King's Sport and Tackle.)

The Russian River Wild Steelhead Society reports that, "since 1870, approximately 40 million hatchery-reared salmonids have been planted in the Russian River System to mitigate against the loss of salmon. Nearly all of stocked salmon came from outside of the Russian River basin. In 1980, a change in understanding about ecological distinctness and genetic fitness of local salmon stocks took place. Beginning in 1990, all steelhead and chinook and most of the coho salmon planted in the Russian River basin are the progeny of adults propagated locally in the Warm Springs Fish Hatchery or the Coyote Valley Fish Facility." But anglers do not flock to the Russian River for the prolific hatchery fish (which are shown in these photographs); the wild steelhead are coveted for their wily ingenuity in escaping capture. (Both, courtesy of King's Sport and Tackle.)

In the photograph at right, June Dyer Jenner hoists a 47-pound chinook caught on August 22, 1962, while trolling near the mouth of the Russian River. Her fishing partner, Joseph Armanini, netted this behemoth after a "40-minute play" up and down the river. (Courtesy of King's Sport and Tackle.)

This fish was caught while trolling with Glen L. Evans. John Parkins rowed the boat to ensure that the fish stayed in deep water. Because chinook spawn in the main stems of rivers, their populations have been less affected by the habitat loss in smaller tributaries. According to a 2012 report by the Sonoma County Water Agency, the chinook returning to the Russian River are offspring of wild parents that spawned naturally in the upper 75 miles of the main stem or in Dry Creek. However, the chinook remains listed as an endangered species in California. (Courtesy of King's Sport and Tackle.)

The Sonoma County Water Agency reported in 2012 that approximately 6,697 chinook returned to the Russian River. "Unlike many steelhead and coho salmon in the Russian River, there is no hatchery production of chinook salmon. Fish returning to spawn are two to four years old. Spawning typically commences in November and continues through January. Eggs incubate in the gravel for roughly two months before fry emerge and begin their downstream migration to the estuary. Water Agency trapping and marking studies have shown that most juvenile chinook salmon enter the Pacific Ocean by July of their first year of life." (Courtesy of King's Sport and Tackle.)

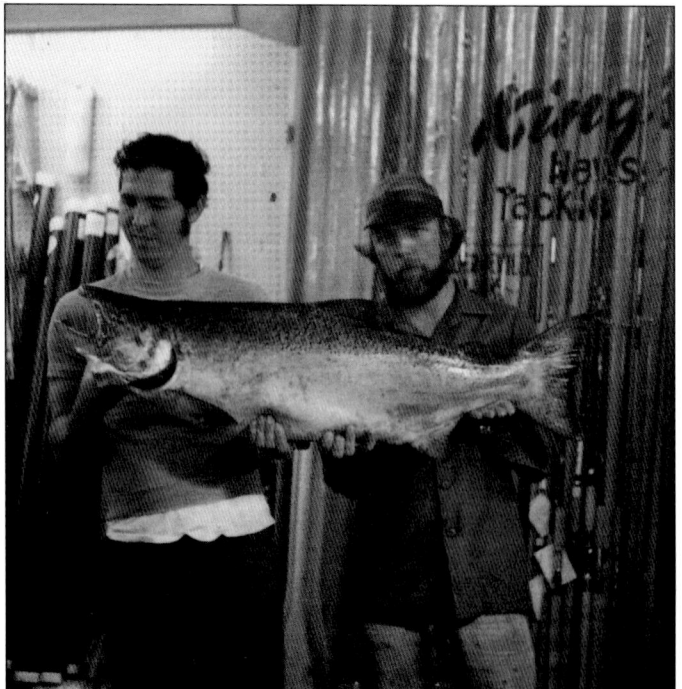

The California Department of Fish and Wildlife estimates that striped bass may consume up to 25 to 50 percent of threatened winter- and spring-run chinook salmon. (Courtesy of King's Sport and Tackle.)

Though each salmonid life cycle varies depending on the species, they all undergo similar cycles. To better understand this cycle, US Army Corps of Engineers fisheries biologist Ben White has provided photographs of the multiple life stages of the coho. Coho, which are listed on the federal endangered species list, are one of three types of salmonids living in the Russian River. This photograph shows viable coho eggs at Warm Springs Fish Hatchery. In the wild, a female coho digs a nest called a redd by using her tail to make powerful swishes in the gravel in the bottom of a stream bed; she will lay approximately 100 eggs per redd. Depending on the size of the female and her location, she will lay between 1,440 and 5,700 eggs total. Once the male's milt fertilizes the eggs, the females will move upstream to dig another nest (redd). In California, coho eggs typically incubate in gravel between November and April. (Courtesy of Ben White.)

Once the coho eggs have been fertilized, they become eyed eggs with dark spots in the center that indicate a growing embryo, as shown in this image. The incubation period depends on the temperature of the water. In California, they typically hatch in about 48 days at about 48 degrees Fahrenheit. (Courtesy of Ben White.)

When the eggs hatch, extremely vulnerable alevin emerge. Alevin remain in the interstices of the gravel for two to ten weeks until their yolk sacs have been absorbed, at which time their color changes to something more characteristic of fry. Freezing, gravel scouring, predation, lack of pools, and excessive silt pose threats to the coho. Simplification of stream habitats and pollutants also affect the fish's mortality. (Courtesy of Ben White.)

The fry are silver to golden with large vertical, oval dark marks along the lateral line that are narrower than the spaces between them. When the fry emerge, they seek out shallow water and the margins of streams, where they form schools. During this time, they feed heavily and grow. The schools eventually break up as individuals claim territories. (Courtesy of Ben White.)

After a year of growth, fry develop into smolts. Through a process called smoltification, they imprint on their natal streams before beginning the journey to the sea in March. On the way, they pause at the estuary at the mouth of the river. This pause is essential for the smolt to grow, put on weight, and develop the physiologic traits necessary for life in the ocean. (Courtesy of Ben White.)

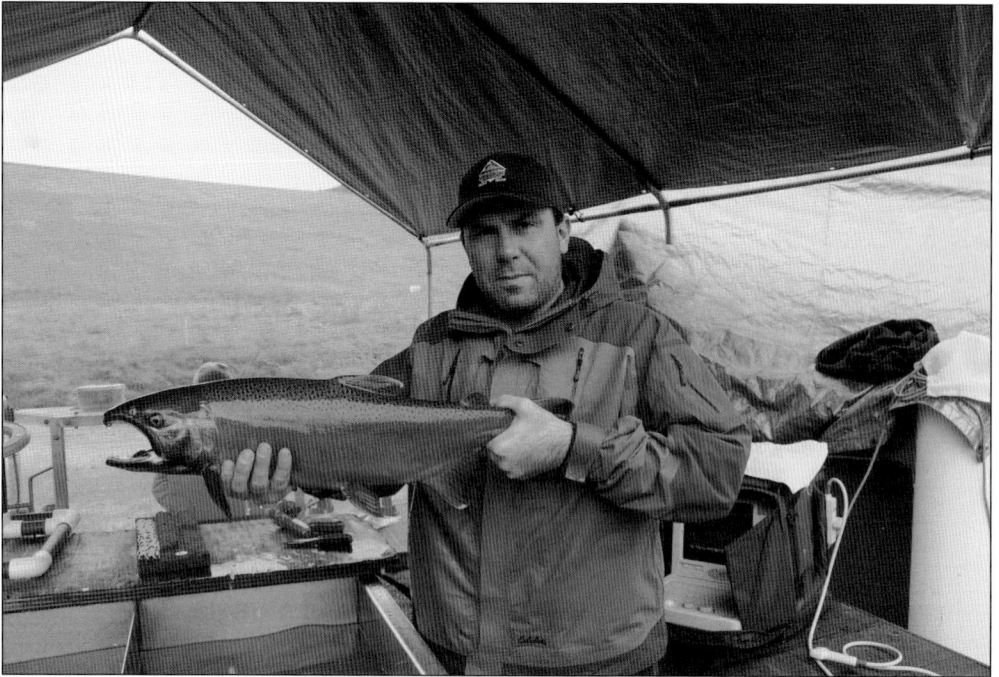

Little is known about coho salmon once they enter the ocean. The immature salmon supposedly remain in schools close to shore as they move north along the continental shelf. Information on oceanic coho is sparse, but they may scatter and join schools from Oregon and possibly Washington. Most remain in the ocean for two years; however, some return to spawn after one year. Coho have been known to travel up to 1,200 miles, though that is not typical. During the spawning migration, coho do not feed—instead, they use their body weight for energy and the creation of reproductive cells. Once they enter their natal rivers, weak from exertion and lack of food, they rest in deep pools to regain strength before finally entering smaller tributaries. (Both, courtesy of Ben White.)

Four

THE TIMBER AND
RAILROAD EMPIRES

As furbearers vanished, trapping revenue faded, and a new economy took hold in Sonoma County—timber. Settlers coming west in search of gold helped cities like Sacramento and San Francisco grew exponentially in just a few years. Sonoma County, with its great stands of old-growth redwood and fir, became a target for lumber companies.

From the mid-1800s through the 1930s, the Russian River watershed was clear-cut, stripped, slashed, burned, and milled to meet the demands of the residents of San Francisco. Lumbermen filled in and simplified complex stream systems to make the movement of logs via oxen easier through steep canyons. These timber management practices devastated the forest ecosystem and decimated the healthy, functioning processes of the Russian River, its tributaries, and its salmon runs.

As hillsides lost their vegetation and root systems, erosion increased. Topsoil slid into the creek beds and filled the gravelly bottoms with fine sediment, which resulted in a loss of habitat where fish could spawn. Riparian plants, such as willow and alder, were torn away to make paths for logs. The loss of this vegetation turned cool and protected waters into warm, exposed death traps for young fish. Incised waterways cut deeper, destabilized banks, and made what had been slow-running creeks raging and inhospitable to juvenile fish. Lumber companies built dams and diverted watercourses to create ponds where logs could be floated for transport—more factors that rendered it impossible for salmon and steelhead to return to the Russian River watershed.

Logging soon became synonymous with railroads. Transporting timber by oxen was slow, tedious, and difficult. To expedite hauling timber to the cities, the watershed took another hit as mountains were blasted, added to, and smoothed over to make way for railroad right-of-ways. Again, sediment loads increased, water was channeled from important fish-bearing streams, and salmon populations plummeted. Topography, geology, and hydrology did little to stop the growing enterprises driven to serve the emerging Redwood Empire in Sonoma and Mendocino Counties.

Massive logging operations in Sonoma and Mendocino Counties vastly changed the character of the landscape. This photograph offers an perspective of the size of the old-growth redwood trees taken down for use in the construction of San Francisco and other nearby cities. Note the full-size horse standing in the center of this ancient tree. (Courtesy of Western Sonoma County Historical Society.)

The men in this photograph from the Emery Escola Collection offer a glimpse at the proportion and scale of the trees felled by early timbermen. This photograph also shows the extent of logging practices at the time—no tree was spared the saw. The only trees left standing were those that could not be used for lumber due to abnormal growths such as burls. (Courtesy of Mendocino County Museum.)

This photograph, titled "There's a Lot of Bull Around Here," displays the largest yoke combination of oxen (eight yoke) photographs in the Russian River area. Note the two bull punchers working the team, which is unusual according to historian Harry Lapham. Also note that the logging area was burned to make passage easier for the oxen and to prevent injury to their faces and eyes. (Courtesy of Harry Lapham.)

Duncan's Mills was once home to massive logging operations. In this photograph, four millhands and a team of eight oxen haul redwood trees from the deep forest to a mill. A corduroy road is also visible. Lumbermen placed sand-covered logs in wet, boggy tributaries to improve travel over often-impassable terrain, and this devastated the watershed for decades to come. (Courtesy of Western Sonoma County Historical Society.)

This c. 1880 photograph shows the end of the epic journey Glynn Mill Lumber embarked upon to deliver lumber to Santa Rosa. Frank B. Glynn Sawmill was located in Coleman Valley near the headwaters of the Dutch Bill Creek. A six-yoke oxen team pulled 10,493 board feet of lumber from Occidental to Santa Rosa. This nearly-16-mile journey took one week. On the way, the team broke every bridge they crossed and often became mired in wetlands. The arduous trip set a perfect stage for the railroads. The tracks that railroads left on the landscape of the Russian River watershed would change the course of salmon runs for untold generations. (Courtesy of Harry Lapham.)

Although trains extended the lumber companies' range into remote areas, oxen were still essential for moving logs from deep canyons and steep hillsides. Here, men transfer logs from oxen to a narrow gauge train. The enormity of the trees logged is shown by the size of the oxen, men, and the train in comparison with the logs they are transporting. (Courtesy of Harry Lapham.)

In the 1890s, Dollar Lumber Company (pictured) sat eight miles west of Guerneville at Sheep House Creek. Remarkably, wild coho still return to this tributary despite the massive development that has taken place over the past 150 years. Past heavy logging, current timber extraction, railroads, and modern cattle grazing all contribute to a loss of habitat in the watershed. (Courtesy of Harry Lapham.)

Berry's Saw Mill, once located at Freeze Out Canyon in the Willow Creek watershed, is now near the site of an effort by multiple agencies, including Stewards of the Coast and Redwoods and California State Parks, to restore Willow Creek. The project releases of thousands of coho, rebuilds bridges for fish passage, and adds wood debris to Willow Creek. (Courtesy of Harry Lapham.)

The Benders Brother's Mill in Del Mar was built in 1890. Although it was north of the Russian River, this photograph shows how the logs were transported from forests to seaside mills, where they were then deposited onto ships and transported to the next destination. (Courtesy of Western Sonoma County Historical Society.)

Once the trees were felled, milled, and carted down the river to the Pacific, they were loaded onto barges for transport to San Francisco. Trees were milled into lumber, shingles, and railroad ties. This c. 1920 shipping schooner was loaded with railroad ties near the mouth of the Russian River. (Courtesy of Fort Ross Conservancy.)

The logging industry boosted the shipping economy and joined with the railroad empire. Each was dependent upon the other. The versatility of the railroad made it possible to tap previously inaccessible tracts of timber, and the railroad could carry away the great logs as fast as loggers could cut them down. This 1931 *Timberman Magazine* advertisement demonstrates the symbiotic relationship of these mutually growing enterprises. (Courtesy of Harry Lapham.)

To expedite the hauling process, railroad workers laid tracks from Marin County to Santa Rosa and west along the Russian River. Another train, a narrow gauge, ran from Sausalito to Freestone, Occidental, and down to Monte Rio. By utilizing these two lines, the timber industry could penetrate into the most remote forests. This 1907 photograph shows logs being hauled from Jenner to Guerneville for milling. (Courtesy of Harry Lapham.)

To help the narrow gauge railways to enter hard-to-reach timber mills, railroad workers would smooth, fill, and drain creek bottoms. Streams once filled with fish ran dry. Vegetation that held hillsides in place was cleared to make way for an emerging economy. This photograph is from the Emery Escola Collection. (Courtesy of Mendocino County Museum.)

Here, two men inspect the erosion, undercut, and incision along a railroad track east of Jenner around 1906. Clear cutting vegetation, overgrazing, and rail cuts for track led to massive erosion damage. This sediment made its way into the estuary at the mouth of the Russian River and altered habitats essential for salmonid smolts. (Courtesy of Harry Lapham.)

To mitigate the loss of habitat, railroad companies built dozens of hatcheries along the Russian River, like this North Western Railway Company fish hatchery photographed by A.O. Carpenter around 1898. Hatchery-raised steelhead were shipped to local streams to supplement existing fish populations. This practice artificially boosted declining fish populations and maintained the sport-fishing industry. (Courtesy of Grace Hudson Museum and Sun House.)

This 1914 Sugar Loaf logging operation for the Sturgeons Mill operation shows two workers stripping bark off of redwoods to facilitate transport of the logs. Tan oaks were also barked for use in tanning hides. The scale of clear-cut and ecological damage is evident in this photograph. (Courtesy of Harry Lapham.)

For millennia, the Pomo prized tan oaks for their nutritious acorns. As settlers encroached, it became nearly impossible for the Pomo to collect acorns. As early as 1814, Californian settlers tanned hides with tan oak bark, and by the late 1800s, large-scale harvesting of tan oaks had ravaged the forests, depleting the understory of valuable nutrients. This drawing illustrates the practice of bark peeling. (Public domain.)

84

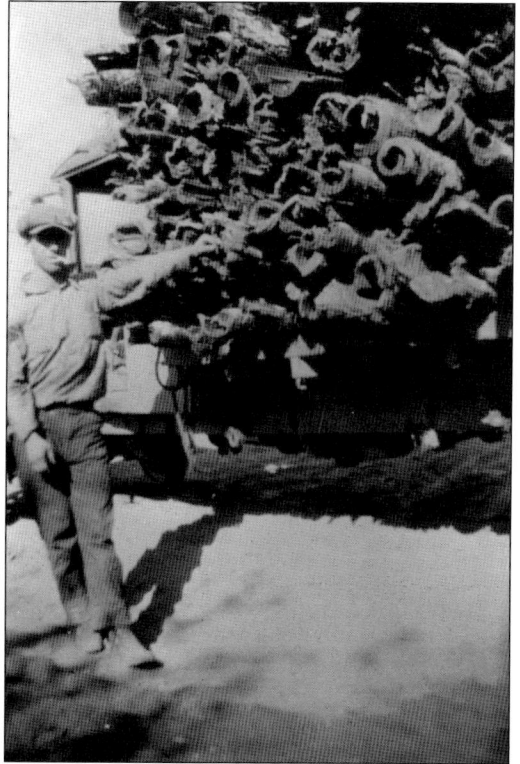

The 1924 photograph at right shows Charlie Beedle with a load of tanbark. During the 1920s and 1930s, tan oak was thought to have become extinct due to the massive extraction of bark stripped from the trees. By the late 1800s, large-scale harvesting of tanbark was driven by consumer demand for inexpensive leather goods. Tanbark was harvested during the peeling season, which lasted from May to July. Two men working together would "ring" a tanbark oak, scoring the tree through the bark at four-foot intervals. In many instances, lumbermen cut down the tree and the stripped the bark, leaving the trunk to rot. The bark was loaded onto mules, wagons, and, later, trucks to be transported to waiting schooners or railroad cars. The below photograph shows tanbark cut from Effie Meeker's ranch in 1926. (Courtesy of Harry Lapham.)

Dick, Carl, Mack, Earl, 1926

This 1895 image shows a horse team dragging a road grader. Graders were used to improve conditions for oxen and for rocking and grading places where people often became stuck in winter. Excess roads—especially poorly-built ones—are harmful to watersheds. (Courtesy of Harry Lapham.)

This c. 1930 photograph shows an earthmover clearing the way for the Redwood Highway (now called Old Redwood Highway). Parts of the roadway have been incorporated into US Route 101, the spine of transportation in Sonoma and Mendocino Counties. When railways discontinued passenger trains, this road became the main route to and from the Bay Area. The road parallels 19th-century railroad tracks. (Courtesy of Mendocino County Museum.)

With the rise in popularity of personal vehicles in the 1930s, more and more road systems began to crisscross the county. The Redwood Highway, pictured in both images, became that main artery in the Sonoma County area. Beyond the erosion and sediment created by logging, trains, agriculture, and grazing, roads also contributed to diminishing watershed habitats. Rainwater sheets off of surfaces and carries debris, chemicals, and sediments into creeks. To ensure the stability the roads, surfaces are compacted and do not let water permeate into the ground. Water then rushes into tributaries, increases flow, and scours vegetation and gravel beds necessary for spawning. These photographs are from the Parkins Collection. (Both, courtesy of Mendocino County Museum.)

1924. DORRIS TRUCK

As the road network continued to spread across the watershed, loggers penetrated deeper and deeper into old-growth forests. Trees that had lived for 1,000 years were felled with little regard for—or knowledge of—their role in a healthy ecosystem. Old-growth trees control erosion, store water in the soil, and keep river systems cool—a necessity for young salmonids. (Courtesy of Bob Sturgeon.)

ISAAC TINNEY 57

As technology advanced, habitat loss increased. Bulldozers made land excavation faster and easier. In a land devoid of ancient trees, residents demolished the hillsides for vineyards, agriculture, and grazing. In this 1957 photograph, Isaac (Ike) Tinney is using a bulldozer to clear his land. (Courtesy of Western Sonoma County Historical Society.)

California's population boomed after World War II. Forests that had been logged by hand, oxen, and trains were now re-ravaged by the advance of technology. With little regard for or knowledge of redwoods' essential role in maintaining natural resources such as water and fisheries, companies continued clear-cutting. Lumber companies returned to already-depleted forests and felled trees left standing because they were initially considered too small. The aerial photograph above shows the Conshea Creek area in the Upper East Austin Creek Sub-basin in 1941–1942 with dense coniferous forest. The photograph below shows the same area in 1961—after clear-cut logging. (Both, courtesy of Laurel Marcus.)

In the Russian River watershed, many streams are incised or entrenched into the floodplain due to rapid and thoughtless development of the land over the last 150 years. When vegetation is stripped, important root systems no longer hold water. The water quickly sheets off the landscape and increases river velocities. Stream channels narrow and deepen, as opposed to the wide, shallow channels that spread across the land naturally for thousands of years. Streams adjust to this change in runoff by eroding beds and banks. As the channel erodes, flood flows become confined to the entrenched channel and move at high velocity rather than slowing and spreading out over the floodplain. High-velocity flows scour out gravel bars, destroying important habitat for salmonids and riparian trees. Because incised streams are typically unstable and function poorly, they are good candidates for stream-restoration projects. Laurel Marcus, of Fish Friendly Farming, works diligently with farmers and vintners to reduce the causes of incision—this is ultimately good practice for both the landowner and fish. (Courtesy of Laurel Marcus.)

Ironically, early trappers on the Russian River extirpated the one species that naturally helped heal the effects of incision: the beaver. Beavers instinctively create wetlands and provide much-needed habitat for coho. Early Russian and Spanish explorers recorded the number of beaver pelts they took from the watershed and their subsequent uses. A recent study from the California Department of Fish and Wildlife reports that water quality is notably improved as beaver dams trap sediments and nutrients and decrease temperatures by hyporheic flow where cooler groundwater mixes with warmer shallow waters. Areas below beaver dams contain reduced siltation of spawning gravels. Deeper and more numerous ponds provide summer and winter habitat for juvenile coho. Beaver-engineered wetlands provide greater food sources for young coho and reduce their energy expenditure during large runoff events, resulting in increased growth and survival. This photograph taken by Jim Coleman shows a beaver dam in Sonoma Creek, near the Russian River watershed. Slowly but surely, as they travel overland and through small tributaries, beavers are making their ways back to the Russian. (Courtesy of Kate Lundquist.)

Like the coho, chinook, steelhead, and beaver, anglers—against all odds—continue to return to the Russian River. Unsustainable logging practices and stripping of the forests continued for decades. In the summer of 1990, multiple organizations came together to hold a massive demonstration in protest of Northern California's lumber industry. The same year, Earth First! called for activists to participate in a series of events meant to mimic the civil rights protests of the 1960s. Several organizations—including Food Not Bombs, Seeds of Peace, and the International Workers of the World—united to organize participants, camps, and logistics. Thousands of activists, demonstrators, and ordinary citizens took part in "Redwood Summer" events. The demonstration ultimately pitted loggers against environmentalists. Deeply-rooted activists in the Russian River watershed continued to act, with locals, government agencies, corporations, and farmers working together. The Dutch Bill Creek Watershed Group, Friends of the Mark West Watershed, the Russian River Watershed Cleanup Committee, Russian Riverkeeper, Russian River Coho Water Resources Partnership, and countless others are examples of such collaborations. (Courtesy of Sonoma County Library.)

Five

THE DAMS

More than 1,400 dams impede the flow of California's rivers, and the Russian River is not excepted from damming. Over the course of the last century, communities along the Russian constructed hundreds of dams for hydroelectric energy, recreation, or water consumption. Unless the dams were purposefully built with fish passage in mind, they prevent migration and destroy valuable habitat.

With the railroad boom, tourists began to come to the Russian River for its "wild" attributes. To boost this economy, dozens of temporary summer dams were and still are constructed for the sole purpose of recreation. As awareness of the negative impacts on river ecology has increased, dozens of these dams have been dismantled. In 1995, the Sonoma County Water Agency funded the demolition of Crocker Dam; the structure's partial collapse created erosion issues and blocked fish passage. In 2003, the Mumford Dam was removed in order to enhance chinook and steelhead habitat on the west fork of the Russian.

Simply taking down dams does not solve the dam conundrum. Three major dam systems on the Russian create numerous challenges for biologists, residents, and agencies.

The Potter Valley Project—a multiple-stage, multiple-dam project intended to provide hydroelectric power for the Potter Valley area—began around 1900. In 1908, the completion of the Cape Horn Dam, for the Van Arsdale reservoir, diverted water from the Eel River into the Russian via a mile-long tunnel. In 1922, Scott Dam was finished, leading to the creation of Lake Pillsbury 12 miles upstream of the Cape Horn Dam. The Potter Valley Project generates 9,700 kilowatts of electricity and provides irrigation water to 390 farmers. It also caused a plummet of salmon and steelhead populations in both the Eel and Russian River watersheds.

Coyote Dam, constructed in 1958, formed Lake Mendocino for flood control, water supply, recreation, and stream-flow regulation. As a result of the dam, a once productive 33-mile fish habitat has shrunk to encompass just four-fifths of a mile.

The US Army Corps of Engineers completed Warm Springs Dam in 1983 to form Lake Sonoma for flood control, water supply, and recreation. To mitigate for the loss of a 139-square-mile watershed, the California Department of Fish and Wildlife operates the Congressman Don Clausen Fish Hatchery (originally called and also known as Warm Springs Fish Hatchery) to replenish steelhead and coho populations.

Amidst all of this dam manipulation, state and federal agencies continue to work diligently to restore the once-healthy ecosystem and its free-flowing lifeblood—the river.

Ann Devincenzi is pictured here in 1954 with her catch of fish from the Camp Rose area on the Russian River. In the 1920s, a road extended from Healdsburg's plaza that allowed people to drive all the way to the river and to Camp Rose. With the extension of this road, the region's Russian River Resort era began, bringing tourists and locals to the beach resort for summer recreation. To ensure deep swimming holes and lakes for fishing, many temporary and permanent dams were created. Few people considered what species of fish lived in the warm, still lakes created by the dams, even if they were nonnative species that devastated the salmon and steelhead runs. By 1935, the road from Healdsburg, which dead ended at Camp Rose, had been extended to reach all the way around the impassable "wilds" of Fitch Mountain. This opened up riverfront lots for the building of summer cabins; most frequently, they were constructed by residents of the Bay Area who wanted restful vacation homes away from the city. (Courtesy of Healdsburg Museum and Historical Society.)

This 1961 newspaper article accompanying this photograph reads: "Too Little, Too Late—Crowds watching the big king [chinook] salmon run that reached Memorial Dam last week, watched the fish hurl themselves into the race and fall back exhausted, many to die, into the deep water below the dam, with the feeling that the job of taking down the dam had come too late. Work on dismantling the structure started Monday evening after 5:00 p.m., when Glen McClish (right) and George Leoni, of the Healdsburg construction firm of Young and Engelke Co. pulled free the four-by-twelve top plank. All planks were expected to be out by Wednesday evening, or today, and the base is expected to come out Monday or Tuesday. In the meantime, while sportsmen and conservationists sought some way to prevent the waste of such runs another year, individuals such as Rene (Frenchy) Revel have been attempting to aid what fish they can over the frustrating height of the dam." (Courtesy of Healdsburg Museum and Historical Society.)

Chinook salmon runs were stopped by temporary summer dams in 1961. A news report accompanying these photos said, "The sight of numbers of the game fish sacrificed through selfishness and bungling has aroused a good deal of criticism of those responsible for this senseless waste of wildlife and an important natural resource. And efforts are already underway not only to prevent this waste ever again, but to prepare for the hazard Dry Creek Dam will offer such fish runs." Due to the number of fish deaths, the Russian River Recreation and Parks District now enforces regulations that require the dismantling of temporary dams along the Russian River and its tributaries each fall. (Both, courtesy of Healdsburg Museum and Historical Society.)

A check for $5.598 million exchanged hands to mark the beginning of the construction of Coyote Dam in March 1956. Pictured here are secretary of the Army Wilber N. Brucker (right) and California representative Hubert B. Scudder looking at the check after it was delivered to Brucker in Washington, DC. (Courtesy of Healdsburg Museum and Historical Society.)

This photograph from the Aginsky Collection shows the town of Coyote Valley before the construction of Coyote Dam and the filling of Lake Mendocino. The old town now lies under thousands of acres of water. With the construction of the dam, the US Army Corps of Engineers had to relocate the residents of the valley, which was subsequently inundated, along with a short portion of State Route 20. (Courtesy of Mendocino County Museum.)

To mitigate for salmonid runs lost after the construction of Coyote Dam and Lake Mendocino, the US Army Corps of Engineers built a Steelhead Egg Collection Facility. This facility collects eggs from steelhead and sends them to Lake Sonoma to hatch. They are raised there for a year, then the yearling fish are returned to Lake Mendocino. (Courtesy of US Army Corps of Engineers.)

The arrival of dams often meant the destruction of fish habitats. Beginning in the late 1800s, more and more government agencies and railroads managed river systems. Railroads not only constructed local fish hatcheries, they transported fish transcontinentally during the great "Fish Car Era." The California Northwestern Railroad Fish Hatchery, located in Mendocino, is shown in this photograph by A.O. Carpenter. (Courtesy of Grace Hudson Museum and Sun House.)

As steelhead and salmon returned to spawn, hatchery workers gathered the adults to harvest eggs from the females and cover them with the milt of males to fertilize the eggs. This photograph, taken by A.O. Carpenter, shows workers collecting eggs. (Courtesy of Grace Hudson Museum and Sun House.)

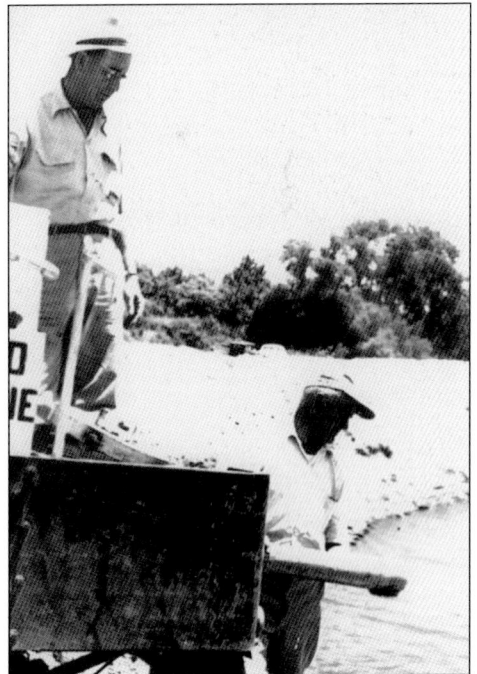

Once eggs had been collected, fertilized, and hatched, the young fry were nurtured until they were large enough to be released back into wild streams. Though plentiful, this stock often lacked the vigor of fish born and raised in natural habitat. This c. 1960 image shows fish hatchery workers releasing fry. (Courtesy of Healdsburg Museum and Historical Society.)

Though the roots of fish hatcheries extend into history, their operations have kept pace with modern technology. To mitigate the loss of spawning habitat for steelhead and coho due to the construction of Warm Springs Dam, the US Army Corps of Engineers constructed the Warm Springs Fish Hatchery coho building at Lake Sonoma. Each year, the facility produces 500,000 steelhead and is the core of an intensive recovery effort for endangered coho. Inside, fingerlings, smolts, and adults are cared for and will be released into viable tributaries at different life stages. Once the fish are ready for release, the coho recovery team reaches out to the public for assistance in returning the fish to the river. Below, children and adults release salmon back into wild habitat. (Above, courtesy of Ben White; below, courtesy of US Army Corps of Engineers.)

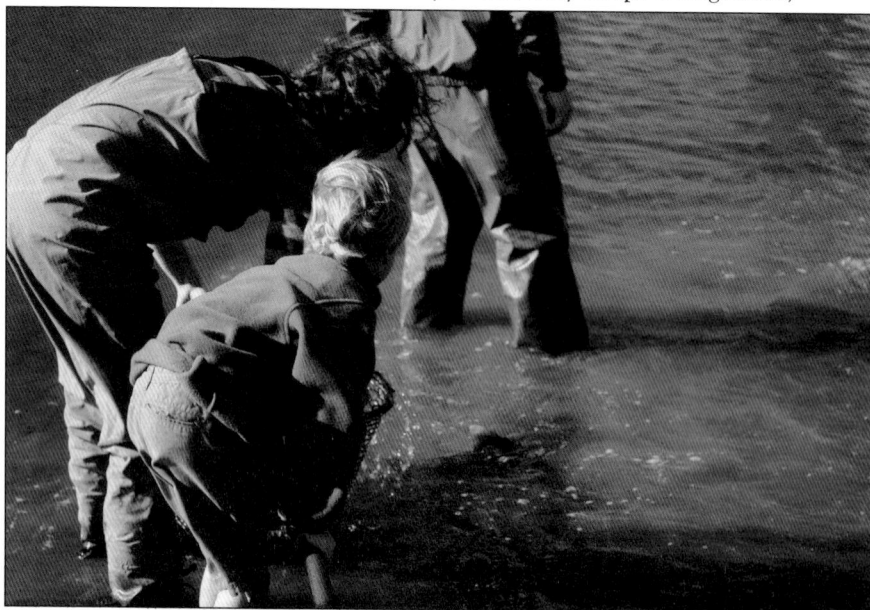

Six

THE RECOVERY OF DUTCH BILL CREEK

Hundreds of tributaries flow into the Russian River, including the 6.5-mile-long Dutch Bill Creek that flows from Occidental to Monte Rio, where it enters the Russian. Prior to the logging and railroad industries arriving in the area, Dutch Bill Creek hosted sacred sites for native Pomo and supported prolific runs of steelhead and coho.

But as the story goes, with industry came ruined watersheds; San Francisco imported trees from the Dutch Bill Creek area, and fish runs dried up. Camp Meeker, the largest town along Dutch Bill, began in the 1800s as a lumber camp but quickly grew into a summer resort. Weekend travelers came north on the railroad to a growing village including two lakes, a community lodge, and summer cottages. For the lakes, hundreds of yards of fine gravel were transported to convert wooded creek banks into sandy beaches. With the luxury of sunbathing came warm, exposed waters—which equal death traps for young salmonids.

By the 1930s, the timber and tourism boom busted, as did the steelhead and coho runs. In the 1950s, with little thought about the possible return of these fish, workers constructed a dam at Camp Meeker. New residents dug wells and lowered the water table. Stream complexes were simplified as members of the Monte Rio Fire Department cleared woody debris from the creek.

Remarkably, even with all of these obstacles, fish lovers and grassroots organizers never lost hope. In the late 1990s, Doug Gore and Brian Hines, of Trout Unlimited, began putting woody structures back in the creek. The Dutch Bill Creek Watershed Group formed, and December 20, 2001, marked the return of the first wild coho in decades. After years of collaboration, the Camp Meeker Dam—which had been identified as one of the worst barriers to salmon and steelhead passage in the Russian River watershed—came down. Each winter, steelhead and coho return to their natal Dutch Bill Creek to write new chapters in their story of recovery.

These petroglyphs—or Pomo cupules—along the banks of Dutch Bill Creek signify the ceremonial importance the watershed held for the native people of the area. Some reports refer to these sites as "baby rocks" and the women's fertility rites that were associated with them. This is merely one explanation; other archaeologists recognize that these sites often occur near anadromous fish runs and water and may have been a place used for inducing rainfall or associated with world-renewal ceremonies. The Pomo may also have honored the internal and external dualities of human life along the banks of Dutch Bill Creek. Note the lines extending from the pits, which differentiate these holes from grinding stones. (Both, courtesy of Karen Vogel.)

In 1910, the Dutch Bill Creek watershed supported a major timber operation started by logging baron Melvin Cyrus Meeker in the 1860s. These photographs show Abial Dodge and his four-yoke oxen team at the Camp Meeker Mill as they hauled logs from the forest for eventual transport on the North Pacific Coast Railroad. In the below photograph, note the clear-cut hillsides in the background. Loss of vegetation and tributary incision contributed to the silting and sediment deposit in Dutch Bill Creek, which once hosted thriving coho and steelhead runs. Remnants of this mill can still be found in Camp Meeker. (Both, courtesy of Harry Lapham.)

This photograph shows the Camp Meeker right-of-way held by North Pacific Coast Railroad. This cut parallels Dutch Bill Creek, which runs from south to north, meeting the Russian River in Monte Rio. The railroad built enormous trestles to span deep canyons and dug tunnels to avoid going around mountains. (Courtesy of Harry Lapham.)

Lumber was carted in from surrounding watersheds and stored in this Occidental train yard in the late 1880s and early 1890s. Downtown Occidental sits at the confluence of both Dutch Bill Creek and Salmon Creek. Both creeks have seen the return of wild coho and steelhead in the last decade; this is a testament to the resiliency of the fish and the tenacity the community has shown toward watershed restoration. (Courtesy of Harry Lapham.)

Once the logging boom ended, vineyards and farms—like the Kling, Speckter, Lapham Ranch in Occidental (pictured here in the 1940s)—took over the clear-cut timber areas. These farms often diverted or pumped water directly out of local tributaries. During certain seasons, a creek could be literally sucked dry in hours, leaving no habitat for fish and other wildlife. In 1994, the state legislature granted the Camp Meeker Recreation and Park District the powers of a California water district; in 1996, the board of directors secured funding to construct a source well in Monte Rio that pumps water from the Russian River to a storage tank on Morelli Lane in Camp Meeker. This water plan leaves more water in Dutch Bill Creek for fish habitats. (Courtesy of Harry Lapham.)

These 1898 advertisements devised by Melvin Cyrus Meeker were designed to bring tourists to Camp Meeker. Meeker wrote, "Taking the train at Sausalito, the whole route from start to finish is one Panorama of Romantic Views . . . Dutch Bill Creek, a beautiful mountain stream, flows through the grounds and a dam has created a magnificent lake where boating and bathing may be enjoyed . . . Besides its accessibility to railroad communication in every direction, Santa Rosa only 15 miles east . . . a house can be built for $25 up."

Though delightful for the residents of Camp Meeker, the dams would prove detrimental to coho and steelhead populations. (Courtesy of Harry Lapham.)

As a resort for people of good moral character, especially families and mothers with children, Camp Meeker also advertised a "LARGE PAVILLION 36x95 feet for DANCING and LITERARY EXERCISES, a HALL and two churches for DIVINE SERVICES." This image shows the Meeker Pavilion and bridge over the lake. (Courtesy of Harry Lapham.)

This photograph from the start of the 20th century shows a dam built near the Camp Meeker Mill, one of the first dams ever built on the Dutch Bill Creek—and one of the first to block fish passage. M.C. Meeker subsequently built other dams to ensure that his growing resort had plenty of water all summer long. (Courtesy of Harry Lapham.)

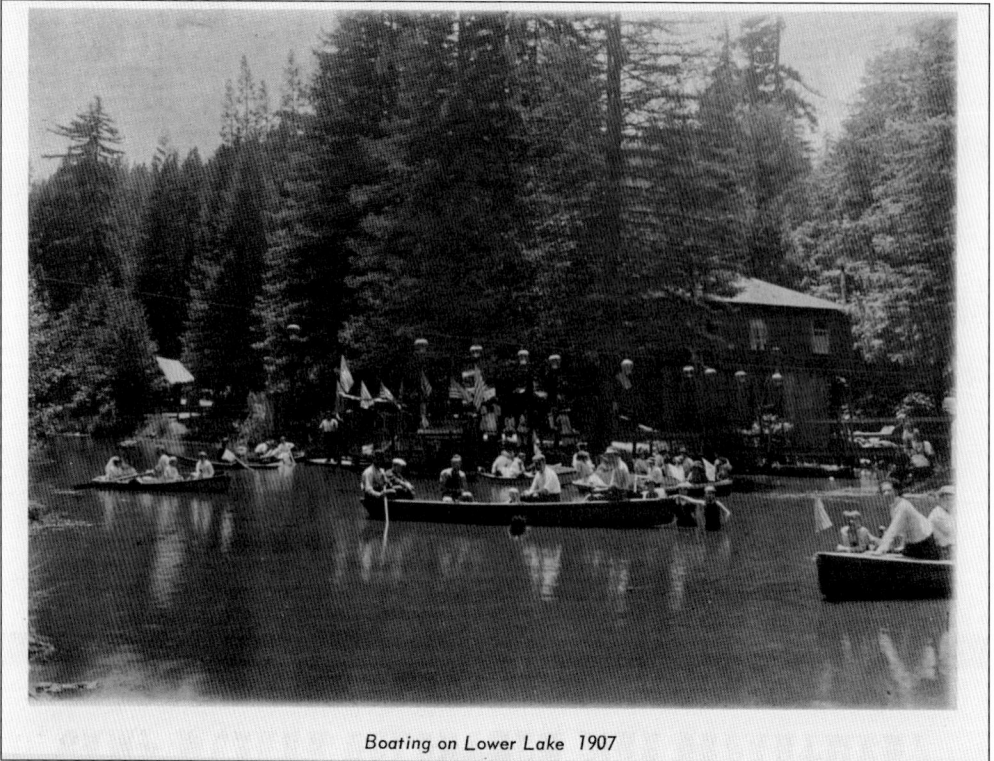

Boating on Lower Lake 1907

M.C. Meeker's original plans for Camp Meeker featured two lakes: Sylvania Lake and Upper Lake, which was upstream. Meeker advertised "A BEAUTIFUL LAKE for BOATING, BATHING AND FISHING; SERPENTINE WALKS to Cliffs, Rocks, Springs, Canyons, Promontory Points . . . BABBLING BROOKS with life giving water, Clear and Sparkling . . ." The 1907 photograph above shows Lower Lake (presumably a nickname for Sylvania Lake). The below photograph shows the bridge over Lower Lake. (Above, courtesy of Bob Sturgeon; below, courtesy of Harry Lapham.)

Over the decades, Dutch Bill Creek has seen many iterations of development and dams. In the 1950s, the Camp Meeker Dam was installed on the creek. In summer, the opening in the center of the dam was barricaded with flashboard to create a swimming hole. Though community members removed the flashboards just before fish migration, increased winter flows shooting through the opening made fish passage difficult if not impossible. The below photograph shows bathers enjoying the Camp Meeker swimming hole. Unfortunately, the dam that created pleasantries for summer tourists spelled disaster for salmon and steelhead whose migration was blocked by enormous concrete walls. (Above, courtesy of Karen Vogel; below, courtesy of Harry Lapham.)

In California's Mediterranean climate, winter brings heavy rainfall and the swelling of Dutch Bill Creek. Though the dam was constructed to let high waters flow through the center in winter, it still presented obstacles to fish passage. Debris often floated down and blocked the dam opening (above), making an already high jump for fish even higher. Though the first coho seen in the area in decades were reported in 2001, they remained below the dam. Increased winter water volumes and velocities poured over the Camp Meeker Dam, making it impossible for steelhead and coho to reach upstream spawning grounds. (Both, courtesy of Karen Vogel.)

In an attempt to help fish migrate, fish steps, or fish ladders, were built downstream of the dam. Fish steps are one of many techniques that aid fish passage. In this case, the steps minimized the height steelhead and coho had to jump from the streambed through the dam opening. Other strategies to improve the Dutch Bill Creek watershed included digging weirs and adding fish baffles to concrete box culverts. Fish baffles allow fish to gain purchase on an otherwise slick surface with shallow water sheeting across it. Watershed activists, including local groups and the Gold Ridge Resource Conservation District, created complexity in a simplified stream system by digging deeper pools and adding woody debris. Structures were embedded into the streambed or bank, anchored to existing trees or bedrock, and weighted with boulders. Starting at the Westminster Woods Camp and Conference Center, conservationists placed a total of 27 structures within the channel along a two-mile stretch of creek. (Courtesy of Karen Vogel.)

After the sighting of coho in Dutch Bill Creek in 2001, conservationists increased efforts to restore wild coho to the system. In 2002, the watershed became part of the Russian River Coho Captive Broodstock Program at Warm Springs Fish Hatchery. That year, 75 wild juvenile coho were collected as broodstock. In 2006, a total of 4,000 juveniles bred through the program were released into Dutch Bill. They continue to be released each fall. In 2009, collaborating groups and residents of Camp Meeker witnessed the dismantling of the Camp Meeker Dam. After the dam's removal, addition of fish weirs and baffles, instream habitat enhancement, a release program, and consistent monitoring of both steelhead and coho contributed to the sight of fish returning to the watershed each year, as shown by this 29-inch steelhead photographed in 2002. (Courtesy of Karen Vogel.)

Seven

THE RESILIENCY OF DRY CREEK

For over 10,000 years, California native people now known as the Dry Creek Rancheria (DCR) Pomo inhabited the lands of Alexander Valley along Dry Creek, a main tributary of the Russian River. Salmon ran so densely that one could supposedly walk on the backs of fish without getting wet, and the fish seasonally migrated up Dry Creek. The banks were lined with important basket-making plants, and the water flowed clear and cool. These ancestral lands supported both the physical and ceremonial welfare of the tribes.

Nonnative settlers began to outnumber California native people around the 1880s, and in 1915, the federal government relocated the DCR Pomo onto 75 designated acres known as the Dry Creek Rancheria. Wealthy vintners in search of fertile soil and temperate climate soon surrounded the Pomo families. With Sonoma County's population on the rise and increased need for water to support a growing wine industry, the US Army Corps of Engineers built the Warm Springs Dam for water catchment. Many of the DCR Pomo protested the dam, because it flooded ancestral lands, inundating village sites and sacred burial grounds.

Following the decline of endangered and threatened salmonid species, a biological opinion was conducted in 2008 for the Russian River and the Warm Springs Dam. The research found multiple issues with the management of the Russian River, including the loss of habitat in and around Dry Creek. To offset these losses, the opinion laid out a timeline that will result in more than six miles of habitat enhancement by 2020.

As the steelhead and salmon show resiliency by returning to Dry Creek against all odds, the DCR Pomo display the same resilient nature by enduring hardships and holding tribal ceremonies to honor the partnership that humans have with all lands, waters, plants, and animals.

MAP 2 NATIVE PEOPLES AND PLACE NAMES

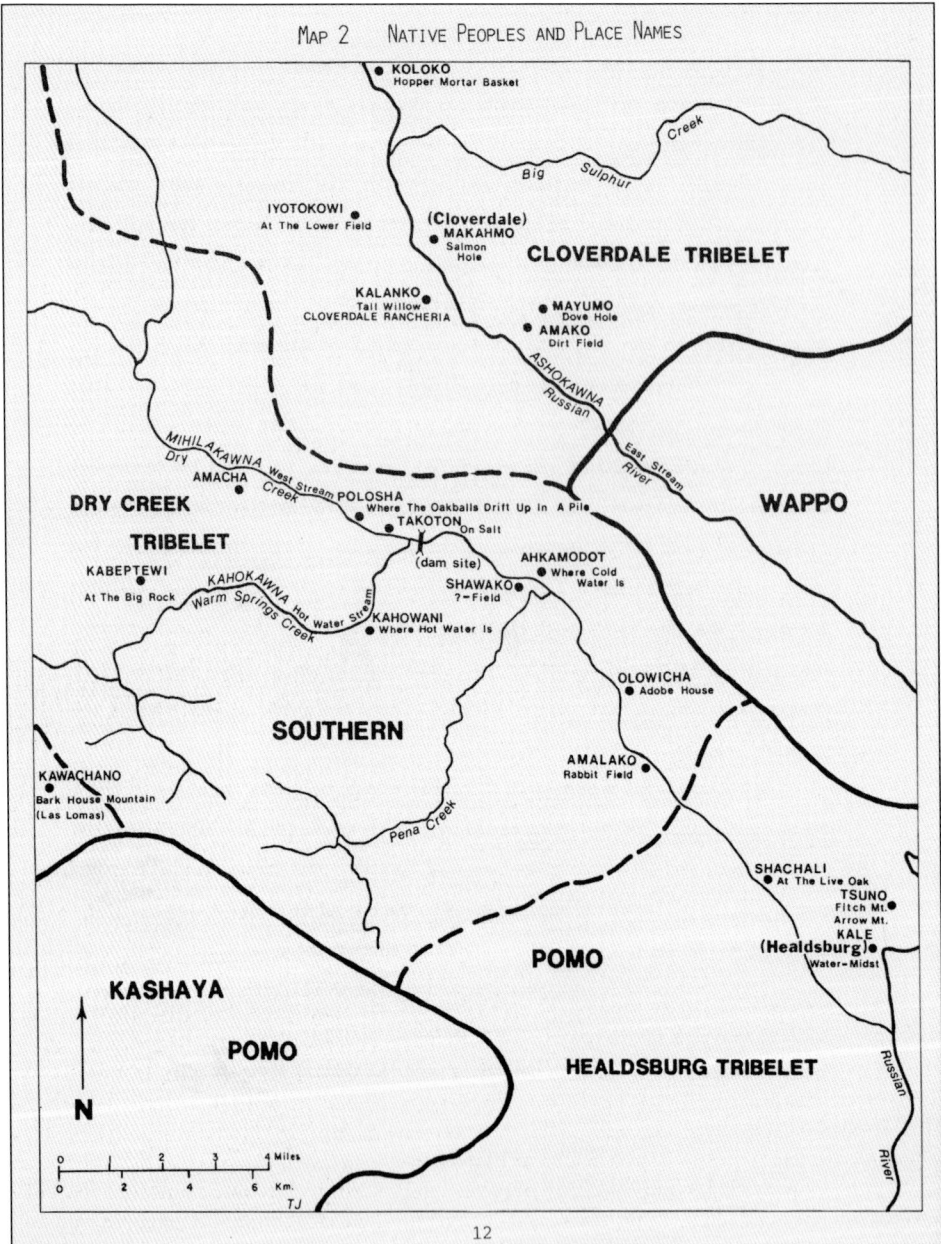

KOLOKO
Hopper Mortar Basket

Big Sulphur Creek

IYOTOKOWI
At The Lower Field

(Cloverdale)
MAKAHMO
Salmon Hole

CLOVERDALE TRIBELET

KALANKO
Tall Willow
CLOVERDALE RANCHERIA

MAYUMO
Dove Hole
AMAKO
Dirt Field

ASHOKAWNA
Russian

East Stream River

MIHILAKAWNA
Dry West Stream
AMACHA Creek POLOSHA
Where The Oakballs Drift Up In A Pile
TAKOTON
On Salt

DRY CREEK

TRIBELET

WAPPO

KABEPTEWI
At The Big Rock

KAHOKAWNA Hot Water Stream
Warm Springs Creek

(dam site)
SHAWAKO
?–Field

AHKAMODOT
Where Cold Water Is

KAHOWANI
Where Hot Water Is

OLOWICHA
Adobe House

SOUTHERN

AMALAKO
Rabbit Field

KAWACHANO
Bark House Mountain
(Las Lomas)

Pena Creek

SHACHALI
At The Live Oak
TSUNO
Fitch Mt.
Arrow Mt.
KALE
(Healdsburg)
Water–Midst

POMO

KASHAYA

POMO

HEALDSBURG TRIBELET

Russian River

N

0 1 2 3 4 Miles
0 2 4 6 Km.
TJ

12

This map shows the diversity and expansiveness of California native people prior to the arrival of European and American settlers. Multiple Pomo villages were located along the shores of what is now known as Dry Creek. The ancestral lands of the Dry Creek Rancheria covered 86,000 acres, some of which is now under Lake Sonoma. In 2012, at the groundbreaking ceremony for the Dry Creek Fish Habitat Enhancement Project, Gus Pina, DCR Pomo tribal elder, stated that the Pomo people had inhabited the Alexander Valley area for over 10,000 years. The DCR Pomo were forced onto 75 acres appropriated to them in 1915, when they received recognition of the tribe as a sovereign nation. California's native population, once estimated at 330,000, dipped down to a mere 15,000 by the early 1900s. Only 1,200 Pomo were recorded in the 1910 census. (Courtesy of US Army Corps of Engineers.)

PLATE 5 – SUMMER FISH DAM

Beyond gathering plants and hunting animals, the Pomo supplemented their diet with the aquatic cornucopia provided by the Russian River watershed. The Pomo ate mussels fresh or dried, made food and shell beads from clams, and collected mollusks and sea anemones from the tide pools on the coast. Waterfowl provided eggs and feathers for baskets. Each year, chinook, coho, and steelhead ran from the main stem of the Russian River into the Dry Creek tributary. To harvest this bounty, multiple families cooperated to build fish weirs. By funneling the fish into a single point, fish weirs provided a large number of easily caught fish to be shared amongst the village. A designated overseer acted as supervisor; this person decided when and where the weir would be built, selected the campsite where the village would stay during the migration, oversaw the fishing, and ensured that ceremonial activities associated with the weir were properly carried out. (Courtesy of US Army Corps of Engineers.)

Efficient harvest of the salmon and steelhead depended on sturdy baskets and strongly woven nets. Healthy riparian vegetation such as willow, sedge, and dogbane provided materials for Pomo weavers. This image shows a sedge bed along Dry Creek that is currently being tended by the DCR Pomo. (Courtesy of Anthony England.)

This stretch of Warm Springs Creek is pictured in 1975 prior to construction of the Warm Springs Dam. Valuable sedge beds and fish habitat vanished at the bottom of Lake Sonoma, which the dam created. DCR Pomo member Anthony England writes, "Some tribal members resisted the formation of the lake, while others tried to work with the US Army Corps of Engineers and land owners to maintain cultural ties to a land they call home." (Courtesy of Sonoma County Library; photograph by Don Meecham.)

In this September 1965 image, Waldo Iverson (left), director of public works, reviews maps regarding Lake Sonoma. The Warm Springs Cultural Resources Study was one of the first large projects started after federal historic preservation laws were enacted in the 1960s. From 1974 to 1984, a team of archaeologists, cultural anthropologists, historians, ethnobotanists, and Native American scholars studied the area. (Courtesy of Healdsburg Museum and Historical Society.)

An article in the June 30, 1966, edition of the *Healdsburg Tribune* reported that, "Huge volumes of dirt are being excavated . . . to make way for the realignment of the road leading to the fish hatchery at the proposed Warm Springs Dam west of Healdsburg. The utility pole, left high and dry by the excavation, stands as testimony to the amount of dirt being removed." (Courtesy of Healdsburg Museum and Historical Society.)

Because of a decline in chinook, coho, and steelhead populations and the 2005 listing of coho as an endangered species, the National Marine Fisheries Service created a biological opinion regarding the Russian River. The opinion questioned whether the flood-control projects of the US Army Corps of Engineers and the Sonoma County Water Agency (SCWA) jeopardized the continued existence of these species and asked what could be done to recover the species. The opinion found "that fast-moving water in the river and Dry Creek makes it difficult for juvenile steelhead and coho to grow and thrive." In addition, high velocities cause incision, as shown in the photograph. Along with the Dry Creek Enhancement Projects conducted by the US Army Corps of Engineers and SCWA, Fish Friendly Farming worked with private landowners to ameliorate problems like erosion and soil loss, stream bank failure, and water quality degradation. These efforts made by farmers not only benefit the environment but also represent cost-effective and efficient land management. (Courtesy of Laurel Marcus.)

Since 1998, Quivira Vineyards and Winery has been actively engaged in restoring Wine Creek, the coho and steelhead spawning stream that winds through the center of the estate. Wine Creek is a tributary of Dry Creek and is subject to many of the same issues. This image shows fish weirs and steps placed in the creek to entice the fish back to the watershed. The winery reports that it is also dedicated to biodynamic farming, "a discipline steeped in science and proven over hundreds of years. It is the opposite of modern corporate agriculture, which has spent years destroying wine country with chemical shortcuts that have upset the natural equilibrium of vineyards. Planting acres upon acres of vine rows is not a natural act. Our winery is a self-sustaining system that includes vineyards, compost piles, chicken coops and vegetable gardens. We live in balance with the creeks that border the estate. We farm within our own constraints and boundaries—which limits production, but improves quality and character." (Courtesy of Quivira Vineyards and Winery.)

According to Quivira Vineyards and Winery: "restoration work on Wine Creek has focused on two main areas: The first involves restoring the gravel beds that are the spawning grounds for salmon and steelhead. The second required pulling back the steep banks and building natural retaining walls using rocks and willow trees. Work included building seven low-fall dams and planting natural grasses to hold the soil and vineyard runoff, as well as moving farm lanes 12 to 15 feet further away from the banks of the creek." In 2010, the California Department of Fish and Wildlife worked closely with Quivira in a restoration project that released 6,600 juvenile coho into Wine Creek. The coho are equipped with a PIT tag that helps estimate efficiency and determines the number of migrating coho and the number of adults returning to Wine Creek. (Courtesy of Quivira Vineyards and Winery.)

The 14-mile-long Dry Creek connects water from Lake Sonoma to the Russian River. Warm Springs Fish Hatchery resides at the place where Dry Creek meets Warm Springs Dam. One of the "reasonable and prudent" options the biological opinion requires is improving the existing coho broodstock program. The Russian River Coho Salmon Captive Broodstock Program is working to supplement the wild coho populations in hopes of restoring them to a sustainable size. Since 2001, a collaborative partnership that includes the US Army Corps of Engineers, the National Marine Fisheries Service, the California Department of Fish and Wildlife, the Sonoma County Water Agency, and the University of California Cooperative Extension/California SeaGrant Extension Program has been breeding coho salmon from local genetic stock at the hatchery and releasing the juveniles into Russian River streams. (Courtesy of Ben White.)

In the above photograph, a fishery biologist keeps a close watch on valuable eggs. During the incubation stage, thousands and thousands of coho embryos are cared for each day. Biologists remove non-viable eggs to lessen the possibility of fungus infecting living eggs. Each tray of eggs represents four different pairings of one female with four different males. This ensures maximum genetic diversity amongst a dwindling genetic pool of wild fish. Eggs are taken from wild coho captured from the Russian River and the next-closest wild genetic sources, Salmon Creek and Lagunitas Creek. (Above, courtesy of US Army Corps of Engineers; left, courtesy of Ben White.)

The broodstock program may keep some young coho to raise at the hatchery, but thousands of coho fingerlings are released in historic salmon-bearing streams each year, as shown in these photographs of Wine Creek. Biologists do not just drop these fish in the water and hope for the best; an extensive monitoring program helps scientists study the lives of these fish and estimate the number of coho returning to the Russian River. Monitoring activities include downstream migrant smolt trapping in the spring, snorkel surveys in the summer, and spawner surveys in the winter. Biologists also track broodstock fish with PIT (Passive Integrated Transponder) tags at all life stages, using antennas spanning the width of the stream and handheld transceivers to monitor the fish. (Both, courtesy of Quivira Vineyards and Winery.)

In the image at left, Ben White releases adult coho back into the wild with hopes of successful spawning. As of February 2014, a minimum of 59 coho had been observed in the tributaries, along with 26 coho redds. Thirty-six PIT-tagged coho returns expanded the total count to 208 based on the ratio of PIT-tagged to non-PIT-tagged fish. (Courtesy of US Army Corps of Engineers.)

In addition to helping with coho recovery, the DCR Pomo also work to recover their lost territory. In the image below, tribal elder Reg Elgin drives an earthmover to help restore the 27 acres the tribe recently acquired though a 125-year lease on Dry Creek. Since 2012, DCR members have been creating a culture center for traditional use, including a ceremonial brush arbor and restored native plants. (Courtesy of Anthony England.)

With all the work along Dry Creek, the DCR Pomo keep a watchful eye on construction workers to ensure that sacred native plants necessary for medicine, food, and practical use are protected. In August 2012, Reg Elgin—who grew up near Dry Creek—prevented workers from accidently destroying beds of sedge (pictured). (Courtesy of Anthony England.)

This fire pit sits at the heart of the newly built DCR Pomo Brush Arbor. This will be a place where, according to DCR Pomo member Anthony England, "the vibrant Pomo culture based on harmony between nature and humans, and continuity between the past and the present" can be practiced, and where "sacred rituals, skilled artistry, and life cycle celebrations are handed down from one generation to the next." (Courtesy of Anthony England.)

An article written by Anthony England reported, "After clearing tall weeds, leveling dirt, digging ditches, creating fire pits, and floating massive redwood trees downstream, Pomo people celebrated the opportunity to gather and build this brush arbor on their land." Upon returning from this celebration, tribal elder Reg Elgin (grandfather of England) said, "This is now hallowed ground. This is no longer only Warm Springs Dam site at Lake Sonoma. This is again home to the Dry Creek Pomo." England also wrote that while "officials continue working to restore the population of coho, DCR fights to preserve and protect their sacred heritage." As the chinook, coho, and steelhead are inextricably woven into the fabric of the Russian River, England's sentiment exemplifies the interdependence humans have with fish. Coho are indicators of water health. If the waters are polluted, degraded, or even being overused, the coho serve as a warning signal when they will not or cannot return home to their natal waters. These fish offer an alarm system that all people should listen to—they are a beacon that can teach everyone how to come home. (Courtesy of Anthony England.)

BIBLIOGRAPHY

Farris, Glenn J., ed. *So Far From Home: Russians in Early California.* Berkeley, CA: Heydey and Santa Clara University Press, 2012.

Parkman, E. Breck. "Pomo Concepts of Power, Spirit, and Place, Rock Art as Visual Ecology." IRAC Proceedings, Vol. 1. San Miguel, CA: ARARA Archives, 1997.

Rivers of a Lost Coast. Justin Coupe and Palmer Taylor, Skinny Fist Productions, 2008.

Stindt, Fred A. *Trains to the Russian River.* Self-published. 1974.

Summer Dam Removed to Create Fish Refuge—Camp Meeker Dam Removal. Ben Zolno and ZoDoCo Productions, 2010.

Swezey, Sean L. and Robert F. Heizer. *Ritual Management of Salmonid Fish Resources in California,* Journal of California Anthropology, Vol. 4, No.1, Banning, CA: Malki Museum Inc., Summer 1977.

Wilson, Simone. *Sonoma County: The River of Time.* Chatsworth, CA: Sonoma County Historical Society, 1990.

DISCOVER THOUSANDS OF LOCAL HISTORY BOOKS FEATURING MILLIONS OF VINTAGE IMAGES

Arcadia Publishing, the leading local history publisher in the United States, is committed to making history accessible and meaningful through publishing books that celebrate and preserve the heritage of America's people and places.

Find more books like this at
www.arcadiapublishing.com

Search for your hometown history, your old stomping grounds, and even your favorite sports team.